D0782978

The Campus History Series

HUMBOLDT STATE UNIVERSITY

The Campus History Series

HUMBOLDT STATE UNIVERSITY

KATY M. TAHJA

Katy M. Tahja

ARCADIA
PUBLISHING

Published by Arcadia Publishing
Charleston SC, Chicago IL, Portsmouth NH, San Francisco CA

Printed in the United States of America

Library of Congress Catalog Card Number: 2009936027

For all general information contact Arcadia Publishing at:
Telephone 843-853-2070
Fax 843-853-0044
E-mail sales@arcadiapublishing.com
For customer service and orders:
Toll-Free 1-888-313-2665

Visit us on the Internet at www.arcadiapublishing.com

*To Westhaven's Jess and Hazel Moon, the best role models
ever for students in the 1960s and our friends for 40 years.*

CONTENTS

ACKNOWLEDGMENTS

Many thanks go to Joan Berman, Edie Butler, and student Katie LaSala in the Humboldt Room of the University Library for their help with the photograph collections. Thanks to all the alumni who donated photographs to the Humboldt Room for the book. All photographs in the book are from the university collection. The Humboldt Emeritus Professors group gave answers to odd questions. Frank Whitlatch, Kellie Brown, and others in the Humboldt State University Marketing and Communications office provided university support and graphic services for the project. My coworkers at Gallery Bookshop in Mendocino accommodated my schedule so I could obsess over deadlines and pitched in typing captions to speed things along. Thanks to Mac McClary, retired Humboldt journalism professor extraordinaire, who has encouraged my efforts on three books and now sees that I really was paying attention in his classes 40 years ago. Finally, thanks to everyone at Humboldt for training me back when my name was Kathleen Alban as a journalist (class of 1970); my husband, David, as a nurse (class of 1972); and my daughter, Fern, as a naturalist (class of 2007). We're loyal alumni!

INTRODUCTION

From humble beginnings almost a century ago on the Redwood Heights ridge overlooking the town of Arcata and Humboldt Bay, this institution of higher learning has flourished. Over the decades, it has been through five name changes, but everyone calls it Humboldt. It's been a mecca for thousands of students on their way to being teachers, professionals, scientists, activists, artists, and protectors of the environment.

It wasn't easy starting a normal school in what legislators in Sacramento considered the middle of no-place, but California needed teachers in rural areas and it was easiest to educate them close to home.

In an era of social progressivism, education had become a national priority, and Humboldt needed teachers. The city of Eureka felt it was entitled to be the home of the new campus due to its population and its status as the county seat, but Arcata's citizens were quicker coming up with donated land for the school to grow on. From 1911, when the planning began, to the spring of 1914, when classes commenced, everyone had high hopes for the fledgling program to educate teachers.

In a recycling spirit that stretches back a century, every time the campus moved to a new location, temporary classroom buildings were carefully taken down and reassembled at the new site. The temporary building for the normal school at the Arcata Grammar School site became temporary classrooms and a dormitory at the teachers college on Redwood Heights.

The first budget for the school was $17,248, and that covered salaries, construction of the temporary buildings, books, and equipment. To attract new students, the Lyceum touring program took Humboldt students all over northwestern California playing music, performing dramatics, and extolling the virtues of Humboldt as a great place to come for an education.

When low enrollment threatened to close the campus during World War I, administrators and the community worked hard to obtain funding for permanent buildings. State funding of $245,000 allowed construction of the building now known as Founders Hall on Redwood Heights in 1922 with classrooms, offices, a library, an auditorium, and a model teaching school on the east side of the building. Primitive playing fields were developed, and a creek was dammed to create a swimming hole for students.

To attract students not planning on teaching careers, commercial courses were developed, as were transfer classes for students headed to the University of California system. To attract working teachers to study, further summer sessions and correspondence classes were available. Nelson Van Matre was Humboldt's first president from 1913 to 1924 and was succeeded by Ralph Swetman from 1924 to 1930.

In 1921 Humboldt State Normal School became Humboldt State Teachers College and Junior College. A community-sponsored College Improvement Association bought land sites for the College Elementary School, now Gist Hall, gymnasium, and tennis courts. A liberal arts curriculum was developed, and in 1926, a four-year curriculum led to a bachelor of arts degree. In 1927, the first football game was held (Humboldt lost), and in 1929, state funding was approved for a gym.

College spirit developed with assemblies, clubs, student government, theatricals, community singing, and yearbooks. Annual workdays occurred where students and faculty alike pitched in to clean and beautify the campus. Enrollment doubled, and in 1930, Arthur Gist became president. He would remain for the next 20 years.

Through the Depression and the World War II years, Gist saw the college through many difficulties. A rise in tuition from $1.50 to $6.50 a semester had industrial arts teacher H. R. "Pop" Jenkins keeping a pot of beans cooking in his building just to keep students fed during the Depression. Threats to close the campus due to low enrollment during the war

were answered by Gist reminding Sacramento politicians that the campus was serving all of northwestern California, an area the size of the state of Indiana, as the only source of a higher education.

A new gym in 1931 and construction of the College Elementary School in 1933 were followed by another campus name change to Humboldt State College in 1935. Nelson Hall dorm was completed that same year, but it would be the late 1940s before Redwood Bowl was completed and football games could be played on campus.

While teacher training was still the main goal of instruction, new liberal arts classes appeared, and forestry, economics, engineering, foreign languages, and home economics were on the schedule of classes. Some folks joked that World War II turned the campus into a girls' school, but enrollment leapt when soldiers returned with the G.I. Bill for education expenses. Surplus military buildings became new classrooms and housing around campus. Wildlife management and forestry became new fields of study. Faculty, enrollment, and degree programs multiplied. Arthur Gist retired at the end of 1949 on a campus far different from the teachers' school he had arrived at decades earlier.

Cornelius Siemens's presidency from 1950 to 1973 was a time of spectacular growth for Humboldt. More than 14 new buildings were constructed, and enrollment grew every year from 1953 to 1973. Hundreds of new instructors were added to the faculty. Students were coming from all over the nation and the world, and new undergraduate and graduate degree programs were developed.

The concept of general education classes as the core of undergraduate learning was developed with Siemens's assistance, as were honors programs recognizing students with "superior intellectual ability." With the region offering unparalleled natural laboratories, degree programs in natural resources, fisheries, environmental resources engineering, oceanography, forestry, wildlife and range management, and conservation were developed. A new nursing program provided nurses for regional hospitals.

The completion of Redwood Bowl with lighting in 1947 led to new enthusiasm for football, and championship football seasons followed, with national recognition and a bowl game in 1960. A roof over the west bleachers in 1954 made rain games more enjoyable. Siemens fought for the funding for the field house so dry ground would be available for physical education classes in the midst of rainy winters.

Humboldt's library flourished under the Siemens administration. A new building to the south of Founders Hall (now Van Matre Hall) served as the library from 1952 to 1962, when the library moved into the center of the campus. The Peace Corps began recruiting on campus in 1961, and more than 750 students joined during the next four decades. The Marine Lab in Trinidad and research vessels appeared during the Siemens era, as did Redwood and Sunset dorms and the Jolly Giant housing and dining complex.

Changes in teacher education laws no longer required a four-year major in education. Any liberal arts major could obtain a teaching credential with a fifth year of study. Recognition of the special needs and concerns of native populations to the creation of the Indian Teacher Education Program.

In the years of the Siemens administration, Greek fraternities and sororities organized, flourished, then slowly vanished with changing social concerns. The 1960s were a time of discontent and rebellion on campus, but under Siemens's understanding and insightful leadership, Humboldt never saw the turmoil other state colleges experienced. The fourth name change to the campus, California State University, Humboldt, occurred in 1972. By the time Siemens retired in 1973, there were over 5,000 students on campus, with 300 faculty members.

Through program growth, a flood in 1964, the Vietnam War protests, coed dorms, the arrival of computers, the institution of parking fees, creation of campus master plans, moving graduation to Redwood Bowl in 1966, a change to quarter-system, debates on enlarging the freeway, the closure of the College Elementary School in the 1970s, and a host of other challenges, Cornelius Siemens provided the leadership needed.

With the next president, Alistair McCrone, taking over in 1974, Humboldt requested its last, and hopefully final, name of Humboldt State University. Change the adjectives of school, college, or university around anyway you want, but everyone just calls the campus Humboldt and has done so for a century.

Humboldt was facing difficult times when McCrone arrived. After years of growth, enrollment was down, state funding had diminished, and fees went up. Higher admission standards went into place, and the eternal student housing crunch persisted. Some things brightened the picture, however.

The National Endowment for the Arts spotlighted Humboldt as a "Model Program in the West." Over $7 million was spent refurbishing Founders Hall, and a $6-million Student and Business Services building went up. Humboldt had more forestry majors than the University of California. A 1993 campus "sleep-out" sponsored by Youth Educational Services raised awareness of the problems of the homeless in the local community.

Humboldt became the first university in the nation to offer a Native American Studies major and continued its reputation as a top source for Peace Corps volunteers. A new Marine Wildlife Care Center was built and rescued 386 birds soiled in a 1997 oil spill in Humboldt Bay. The First Street Gallery opened in Eureka, featuring student and faculty artwork. The Campus Center for Appropriate Technology's solar panel system fed power into utility power lines instead of using it.

U.S. News and World Report listed Humboldt as a regional "Best Buy" and *Money* magazine's college guide said the campus was "worth a special look." The Graduation Pledge for social and environmental responsibility was created by students and spread nationwide. An attempt to replace the Lumberjack mascot as outdated was voted down after suggested names like Indica Buds and Tofu Eaters were derided.

By the time Alistair McCrone retired, Humboldt had the largest herbarium in the California State University system with 190,000 specimens, and a fisheries collection of 46,000 items was the fourth largest in the state. Humboldt has grown while facing challenges under McCrone's 26 years of leadership.

Rollin Richmond, Humboldt's sixth president, is now leading the university into its centennial celebrations. He believes Humboldt should be a role model for community involvement and that it should promote social and environmental responsibility. Humboldt's partnership with the local community stretches back almost a century. Local political and business leaders helped convince state lawmakers to create this institution, and they found donations of land and other resources to make it possible. President Richmond has worked to strengthen that connection, in part through the creation of the Office for Economic and Community Development. He has also worked on area initiatives to increase access to digital technology in underserved rural areas and to bolster rural health care.

Under President Richmond's leadership, enrollment has reached record levels. Important new facilities have been built, including a five-story classroom building, a kinesiology and athletics building, and new residence halls. New partnerships have been created with universities overseas, and enrollment of international students is growing quickly. He has also bolstered the university's ability to attract grant funding for research and special projects.

This president is proud that Humboldt is consistently recognized by *Princeton Review* as a "College With a Conscience" and a "Best in the West" school as well as a top public master's level university by *U.S. News and World Report*. He also enjoys Humboldt's quirky culture and unique experiences, like student juggling demonstrations on the quad, wild animal spotting on campus, and any appearance by the irreverent Marching Lumberjacks. Then there was the student fashion show in 2005 that featured garments made of objects from trashcans, and who can forget Prof. William Wood's discovery that "toe jam" between deer hoofs has antibiotic properties? As it approaches its centennial, Humboldt remains a truly unique institution of higher learning with loyal alumni supporting it. What will the next century bring?

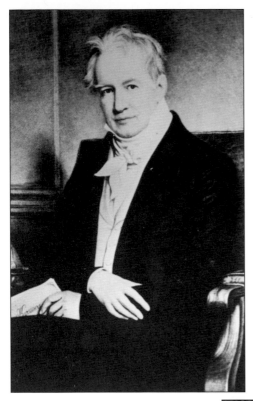

Alexander Von Humboldt, for whom the university is named, never saw Humboldt County, or California. The first Americans sailing into Humboldt Bay on the *Laura Virginia* in 1850 named the area in recognition of this world explorer. Born in Prussia in 1769, he was an educated explorer and scientist who traveled the world and fostered collaboration among scientists, geographers, geologists, astronomers, biologists, and ecologists.

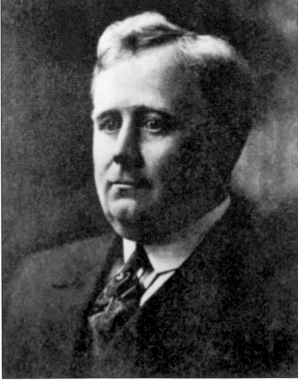

Nelson Van Matre was the first Humboldt president, serving from 1914 to 1924.

One

VAN MATRE PRESIDENCY
1914–1924

In March 1914, Humboldt's first president, Nelson Van Matre, was appointed. A Midwesterner with a doctorate in education from the University of Chicago, he had taught in the Midwest and California for 15 years. Tackling his new job, he oversaw the construction of temporary buildings, found accommodations for students, attracted faculty, and offered classes to 63 students starting in May 1914.

Preparing to be a teacher was serious business to Van Matre, and he scrutinized candidates. Men would wear blue suits and white shirts and women were not allowed bright colors. Clean, wholesome athletics were allowed, as were drama and music, and 18 subject areas were to be studied for a credential. A grammar school of five grades was held on campus so that students could practice teaching skills.

With a donation of 51 acres of hilltop land and $91,000 in state funding for buildings and equipment, the teachers college moved up the hill in 1916 into temporary quarters. Enrollment went up to 156, and Van Matre wanted permanent buildings for his fledgling institution. World War I lowered enrollment, and for a time, Sacramento threatened to close the campus. The state withheld funds for permanent buildings until the 1920s.

A new name, Humboldt State Teachers College and Junior College, came with the 1920s. Junior college classes preparing underclassman to enter the University of California joined a four-year teacher-training curriculum. In 1922, the first permanent building, Founders Hall, was ready with classrooms, offices, a library, an auditorium, and a training school. The temporary building was carefully disassembled and reconstructed as a dormitory where Nelson Hall stands today.

Land was purchased for a gym and tennis courts, and a creek was dammed for a swimming hole. By 1922, the faculty had grown to 16 members, students could study four foreign languages, commercial courses were available, and vocational training expanded.

Van Matre in his tenure had been the admissions officer, registrar, program advisor, and financial controller. He organized Arcata's businessmen to support the school's programs and developed curricula aimed at meeting the needs of grammar school teachers. In 1924, Nelson Van Matre retired.

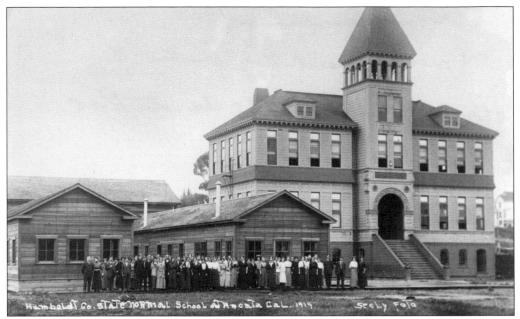

Students of the Humboldt State Normal School line up in front of their temporary quarters in 1914. The Arcata Grammar School towers over the scene near Eleventh and M Streets. Future rural elementary school teachers learned general education skills along with physical culture, penmanship, bookkeeping, drawing, and more in a two-year course of study.

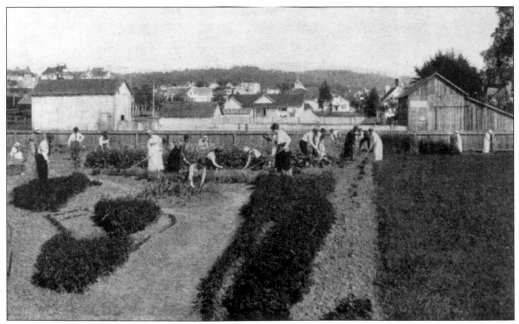

In 1919, vocational training was a part of a normal school education. Included in this were agriculture, horticulture, domestic science, manual training, and music. These courses were considered utilitarian and educational. Agriculture class included soils, farm crops, plant diseases, livestock, and practical applications to school and rural life.

In 1913, the donation of 51 acres of ridgetop lands by William Preston and the Union Water Company assured placement of the college campus in Arcata and not Eureka. Stumps from prior timber harvests had to be cleared before the new campus could begin construction in 1915.

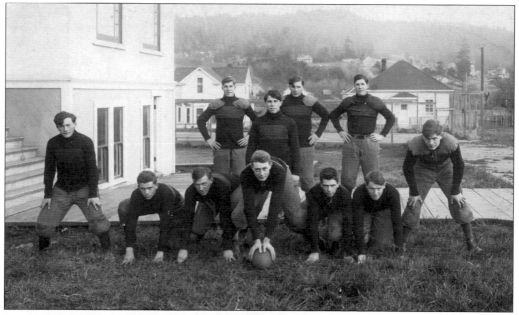

In a small new school like Humboldt, every available male was shanghaied to provide enough members for a football team. In the first decade of the school's existence, a football game was played against Fortuna High. Humboldt lost by a wide margin. In the 1920s, all third-year students in teacher training had to practice-teach and could not engage in athletic competition.

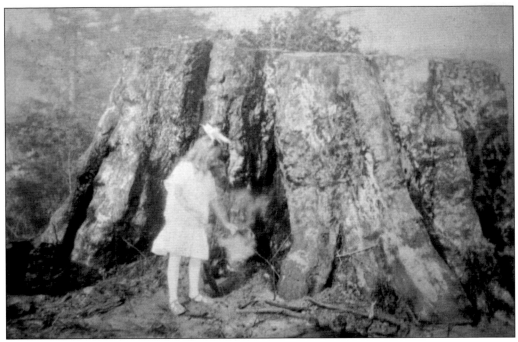

And how was the future normal school site cleared of debris? Dynamite! Mary Estelle Preston lights a dynamite fuse to blast the first stump from the site of Founders Hall. Miss Preston went on to become a teacher, trained at Humboldt, was a supporter and land donor, and was crowned Homecoming Queen in 1988, when distinguished alumni served as royalty.

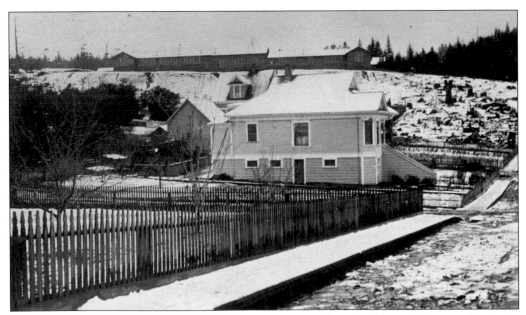

In a rare snow-covered view of Arcata, the temporary college buildings fade into the sky in the early 1920s. Construction had not yet begun on Founders Hall. William Preston, who donated the ridge top, lived where the campus library now stands. Today's Art Building covers the site where the first college president, Van Matre, had his potato patch.

On May 26, 1915, the first graduating class had commencement. They had each been given the fabric to make their dresses. In teacher training, they practice-taught seven different subjects to several different grades for 70 weeks. Busy all week with practice student teaching, these adults attended regular classroom instruction on Saturday.

Talking about Humboldt is almost impossible without talking about redwoods. New students arrive and discover that if they hike east of Redwood Bowl, the forest seems to go on forever. The Arcata community forest offers miles of hiking trails. The tallest redwoods in the world are an hour's drive away. Humboldt has always publicized and taken great pride in the beautiful natural environment surrounding the campus.

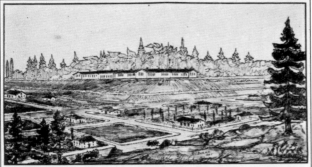

Humboldt State Normal School on Redwood Heights

The architect's conception of what the campus atop Redwood Heights would look like and what was actually built varies only slightly. While Founders Hall looks the same, the two wings of two-story classrooms were never built. Students and faculty moved into the building in 1922.

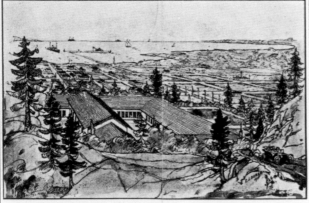

View of Bay and Ocean from Normal Heights

The view from the new campus site, here shown decades later, was impressive. Arcata, and the wood smoke from homeowner's wood heating stoves, fades off toward Humboldt Bay, the Samoa peninsula, Eureka, and the Pacific Ocean. Generations of Humboldt students have stood on the hilltop and enjoyed the stunning view.

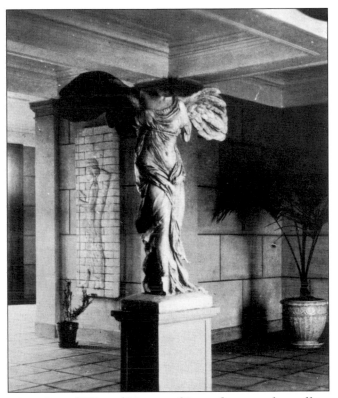

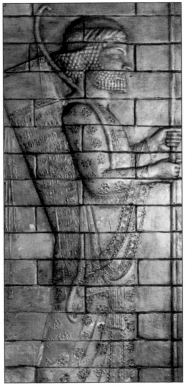

A replica of *Winged Victory of Samothrace* and a wall sculpture of an Assyrian warrior lent a note of antiquity to the newly completed Founders Hall entrance hall. Copies of the Elgin Marbles flanked the auditorium along with classrooms, offices, and a library. It opened its doors in 1922. In a precursor to Humboldt's recycling habits 80 years in the future, part of the old temporary classroom buildings on Preston Ridge was carefully taken down board by board. Lumber was transported down the hill piece by piece to be rebuilt as a 50-person dormitory on the site of today's Nelson Hall. Land donor Preston had specified a swimming pool be built on property he granted to the college, so an 8-foot concrete wall was constructed on the stream above Jolly Giant Canyon for a chilly but invigorating swim site.

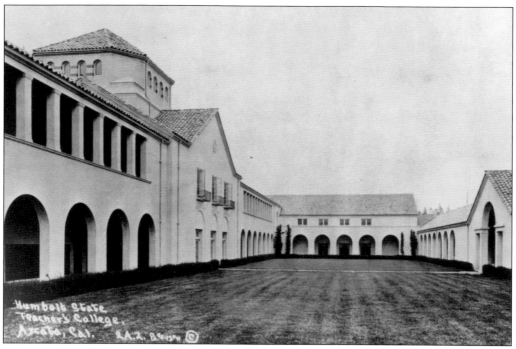

Humbolt State
Teacher's College,
Arcata, Cal. R.A.Z. Benson ©

Funds of $245,000 produced
a grand new building for the
Humboldt State Teachers College
as the name Normal School passed
from use. Built in a Spanish style
dictated for all public colleges in
the state, the arched alcoves were
pretty but drafty and were soon
glassed in. The building included a
training school for 250 children.

Ralph Swetman was the second
Humboldt president, serving from
1924 to 1930.

Two

SWETMAN LEADERSHIP
1924–1930

Humboldt's second president, Dr. Ralph Swetman, was in love with nature and loved leading hikes for students and faculty. Arriving from Stanford University full of enthusiasm and idealism, he was intent on making Humboldt a school centered on educating children. Faculty increased to 20 teachers, and high academic standards were expected of all students. Swetman expanded library resources and appointed the first college librarian in 1925.

Student publications appeared, and clubs were organized. The Lyceum toured to educate and entertain throughout Northern California with dramatics, vocal and instrumental music, ballet and jazz dancing, acrobatics, oratory, and invitations to come get an education at Humboldt. The 1926 tour reached 5,000 people, and the group, renamed the Collegians in 1929, entertained 1,675 people in a two-night appearance at the Minor Theater in Arcata.

Athletic competitions began, and Humboldt athlete Elta Cartwright ran through local, state, and national competitions all the way to the 1928 Amsterdam Olympics. The first intercollegiate football game was played in the fall of 1927 against Southern Oregon Normal School, and Humboldt lost 33-0.

Ill feelings had existed between Eureka and Arcata for over a decade over the controversy surrounding the location of the campus. Swetman worked to close this gap and develop a spirit of goodwill where everyone on the north coast would support the college. In 1928, the Improvement Association provided scholarships, loan funds, research grants, band uniforms, and travel funds and obtained land donations for the campus.

In 1925, the first zoology instructor was hired and began the process of making Humboldt world-renowned for studies on the natural environment. Founders Hall saw improvements with a red tile roof in 1925 and $6,000 spent to glass in the alcoves in the courtyard.

In an honor that would have pleased Ralph Swetman, in March 1980, the Child Development Laboratory on campus was named in his honor. Here the children of staff and students at Humboldt and those of community members are offered a preschool educational program. Swetman served the campus well for the six years of his presidency.

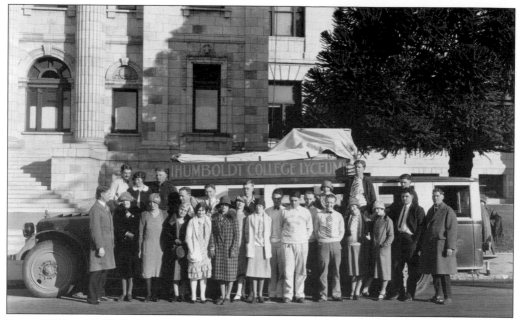

From 1925 to 1930, in an attempt to attract new college students to the far north coast of California, a traveling show of Humboldt student musicians, dramatists, orators, and performers journeyed south to San Francisco and north to Oregon, stopping in every small town and introducing the college to the rest of the world. Chaperones and teachers joined them on the bus.

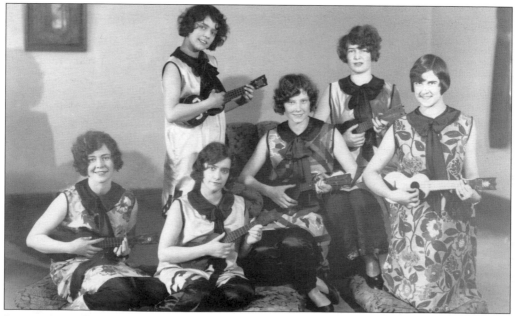

In costume with ukuleles, these women were part of the touring Lyceum or Collegians group in 1927. The same women appear in other costumes dancing, singing, and being theatrical in other photographs. Under Swetman's presidency, school spirit was encouraged. The ukulele players were, from left to right, Leona Simms, Ella Woolner, Mary Shields, Virginia Herion, Ester Stewart, and Maxine Scott.

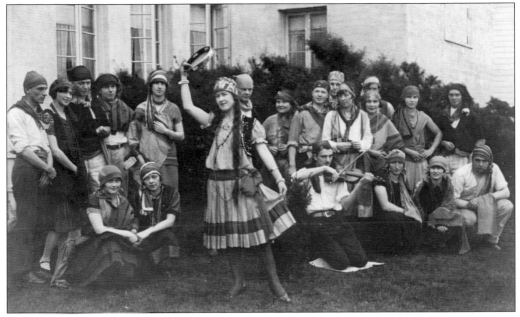

A dramatic production with a gypsy theme involves 20 students and a violinist in this 1920s photograph. The term "Lyceum" covered operas, chorale, glee club, orchestra, and dramatic performances offered to the public on campus or on tour in northwestern California. To participate in such activities, Humboldt students needed to be passing in 10 units of study and pay student body dues.

The social page from the 1927 *Cabrillo*, the Humboldt State Teachers College yearbook, captioned this photograph "In the Days of 49." Eighty years later, it leaves readers to wonder. Was it a dramatic performance, a Lyceum skit, or a resident hall Halloween costume ball? The *Cabrillo* featured photographs of 82 graduates and 25 faculty.

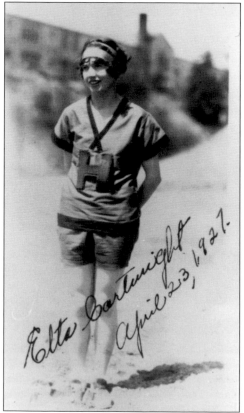

The male student body officers of 1927 were, from left to right, Herbert Yocum, Ben Feverwekers, Gerald Collins, Monroe Spaght, Wilber Ellis, Daniel Synnes, and Verner Haapala. Women were Ruth Ballard, Elenor Yocum, Elise Ray, Elta Cartwright, Aileen Barrett, and June Shields. Spaght, the student body president, became one of Humboldt's most illustrious alumni, graduating from Humboldt, going to Stanford, and becoming president of Shell Oil and later Royal Dutch Petroleum.

Humboldt's first superstar athlete was Elta Cartwright, who set records as a runner with Humboldt's women's track team. In 1927, she was breaking national records, and in 1928, she was on America's first women's Olympic team in Amsterdam. Defeated in the semifinals, she was still a local hero. She became a teacher and was Homecoming Queen in 1981, when alumni were Homecoming royalty.

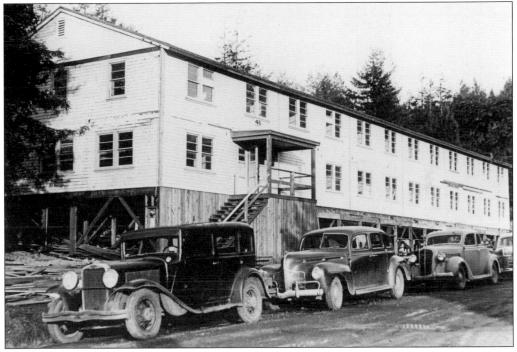

Every college had a corporation yard, where equipment for maintenance of buildings and official vehicles were kept. In the 1920s, the parking spaces under the temporary buildings served that purpose. If materials couldn't fit under the buildings, they were just stacked outside. It was primitive, but it worked.

Dormitory rooms were austere in the 1920s. The single dorm where Nelson Hall now stands had wings for male and female students and a shared social unit in between. Students brought their own bedding, and local lumber mills provided scrap wood for the woodstove heaters. Rent was $7.50 a month and an extra $20 for two meals a day.

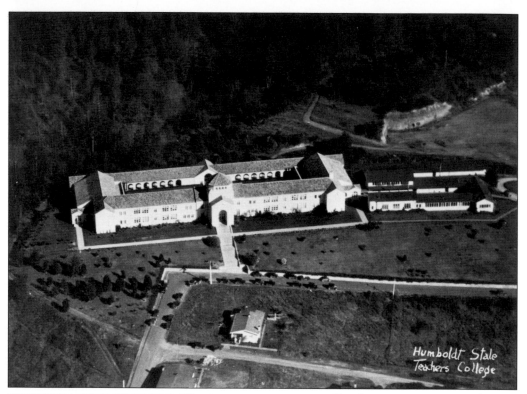

Humboldt State Teachers College

Here's a trivia question: what was the name of the street in front of Founders Hall? It was Cedar Street! In this aerial view from early years, the new building is still sharing the hilltop with temporary quarters. The beginnings of an athletic field show to the east of Founders. Parking was yet to become a problem.

Luffenholtz Beach, north of the campus near Westhaven, is a favorite student getaway named for Baron Carl von Luffenholtz of Germany, an early settler. There was a lumber mill nearby in 1851. Soon a town sprang up with 30 families, a railroad depot and service facilities, a store, a post office, and a shingle mill. A fire destroyed everything years later, and only Luffenholtz's name remains.

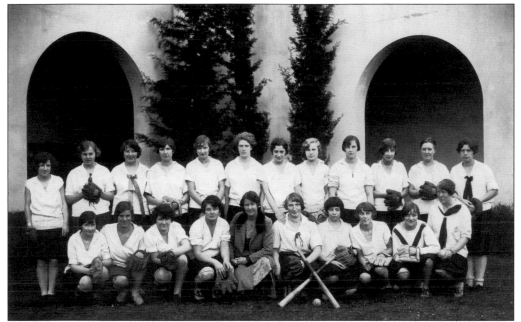

The women's softball team of 1926 affirms the popularity of sports on campus. Women's intramural sports also included volleyball, field hockey, basketball, track and field, archery, and golf. College president Swetman and college librarian C. Edward Graves were avid hikers who took students out with them. Men's sports had problems, as most of the student body was female. Only 12 men turned out for the first football practice in 1927. Insurmountable transportation difficulties back then meant playing local teams. The Civilian Conservation Corps workers from Prairie Creek and Orleans provided basketball teams for competition with men like these below. In 1939, the name "Lumberjacks" was adopted for sports teams.

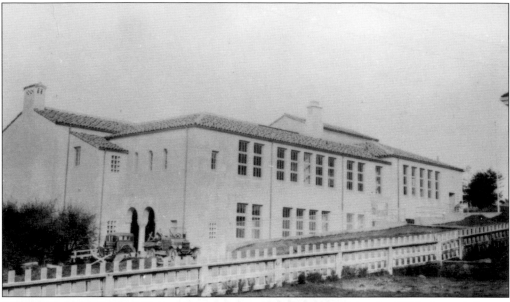

In 1939, the training school occupying the west wing of Founders Hall moved into the new College Elementary School. Planned as a concrete expression of the college's educational philosophy, its interior design reflected the desires of Pres. Arthur Gist and professors. It had eight classrooms, a manual training room, a library, a gym, and a playground. The exterior complemented the Founders Hall Spanish motif with a red tile roof.

Arthur Gist was the third Humboldt president, serving from 1930 to 1950.

Three

GIST AT THE HELM
1930–1950

The great enthusiasm for teacher training third president Arthur Gist brought resulted in the fullest development of teacher education Humboldt ever saw. Gist was a graduate of the University of Washington, an author, and a former director of education at San Francisco State Teachers College. He arrived during the Depression and allowed students to submit IOUs for rising tuition fees for one semester to keep them in school.

Enrollment grew, curriculum expanded, and in 1935, the campus got its third name: Humboldt State College. A new gymnasium was built in 1931, and the College Elementary School was completed in 1933. When not in classes, students could participate in traditional social activities like proms, banquets, all-school picnics, pancake feeds and salmon bakes, clubs, student government, and athletics were available to students. Football was played at Albee Stadium at Eureka High, because Redwood Bowl was still undeveloped. Nelson Hall dormitory was completed in 1935.

While teacher training was still the number-one goal of instruction, there were commercial, pre-professional, and non-teaching classes offered. World War II caused enrollment to drop to 159 in the spring of 1945. People joked the college looked like a school for girls. A stamp shack in front of Founders Hall sold war bonds and stamps with a goal of raising $1,165 to buy the Army a jeep. Gist arranged for all military men from Humboldt to receive *Humboldt News Letters* for two years with all the news from home.

The end of the war brought an enrollment jump as soldiers returned to campus on the G.I. Bill. Surplus military buildings became Redwood Hall dorm for men and Humboldt Village (called G.I. Village) for married student family housing. By 1947, Humboldt could offer secondary teacher credential training and two-year programs in forestry/lumbering and agriculture/dairying.

In Gist's 20-year tenure, which ended in late 1949, Humboldt doubled the faculty, more than doubled the student body, and increased the degree program tenfold. In honor of Gist's commitment to teacher education, the building that once held the College Elementary School is now called Gist Hall.

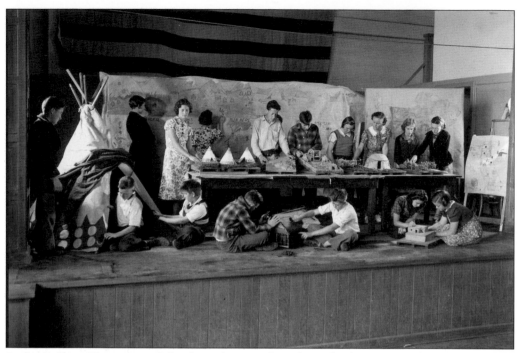

At the College Elementary School, students and teachers display a "unit of work." This unit seems to have been early housing in North America, as tepees, log cabins, bark wikiups, and a pueblo are displayed and students decorate the background posters in 1938. Most student teachers under training here came from northwestern California.

ALMA MATER

Far above Pacific's waters,
With its waves of blue,
Stands our noble Alma Mater,
Glorious to view,
Hail, all Hail to Humboldt College,
Loud her praises sing,
Hail to thee, our Alma Mater,
Hail, all Hail, all Hail.

College Life is swiftly passing
Soon its sands are run,
While we live, we'll ever cherish,
Friendships here begun.
Hail, all Hail, to Humboldt College,
Loud her praises sing,
Hail to thee, our Alma Mater,
Hail, all Hail, all Hail.

Here are the words to the Humboldt alma mater, and here are some trivia questions on this institution. What are the school colors? They are green and gold. What is the meaning of the school's Greek motto? It stands for truth and light. How many courtyard archways surround the lawn at Founders Hall? Visitors find 39 of them. What American Indian tribe occupied what is now Arcata? The Wiyot lived here.

From high above in 1938, the campus is beginning to take shape. Temporary buildings still share the hilltop with Founders Hall. A gym has been built on the upper right, and dorms are in the middle left. Tennis courts and parking are downhill from Founders Hall along Cedar Street. The Co-op is under construction, and the College Elementary School has been completed on the middle right.

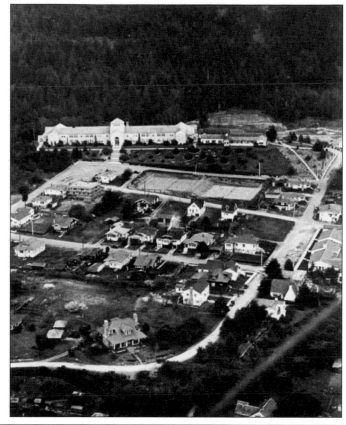

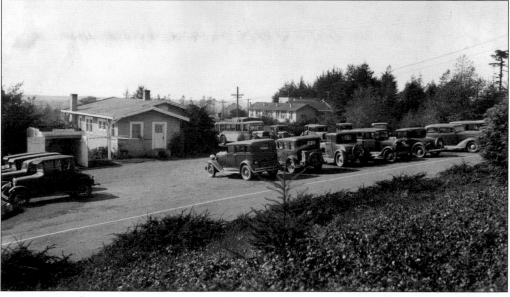

In the 1930s, finding a parking space didn't involve the frustration commuters experience today. Motorists drove up Plaza Avenue or Laurel Drive and parked where the University Center sets today. Tennis courts were to the left, just out of sight. Enrollment was about 400 students, and temporary dorms are visible above the parked cars.

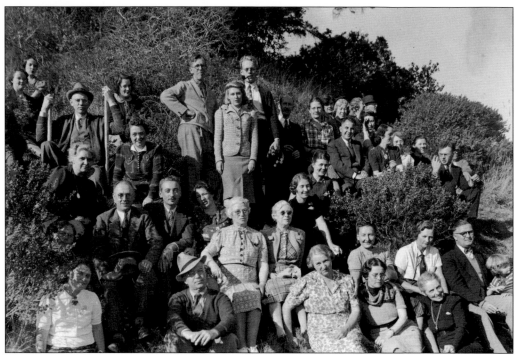

A 1938 faculty party at Stella Little's cabin at Moonstone Beach found a close circle of friends. Faculty who served before 1950 were called Buffalo Heads and remembered when the faculty lived on campus and everyone knew everyone. Times changed, the campus and faculty grew, and one by one, the Buffalo Heads retired.

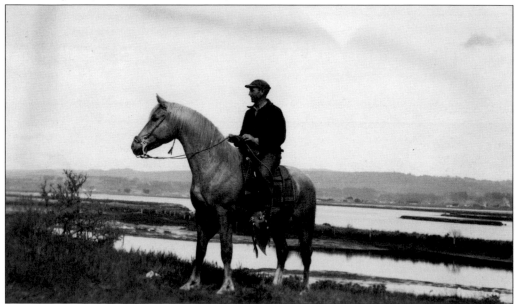

There are not many old photographs of Humboldt faculty on horseback, but here is William Lanphere at his ranch on the Arcata bottoms. Today that area is called the Lanphere-Christensen Dunes and is part of the Humboldt Bay National Wildlife Refuge complex. Lanphere and his wife, Hortense, taught the first wildlife management courses in the 1940s.

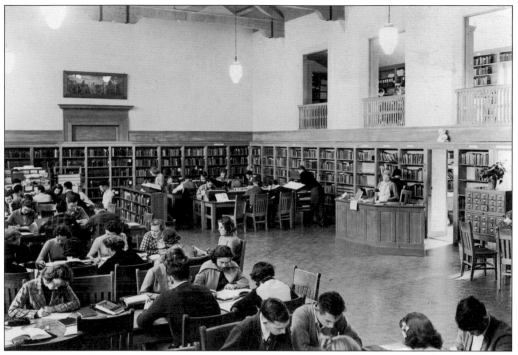

The library in Founders Hall occupied the south side of the structure. A mezzanine housed a magazine collection and looked down on a room with book-lined walls. The collection began with 1,000 books and kept growing. In the 1920s, C. Edward Graves was the first librarian. It would be the 1950s before the library got its own building.

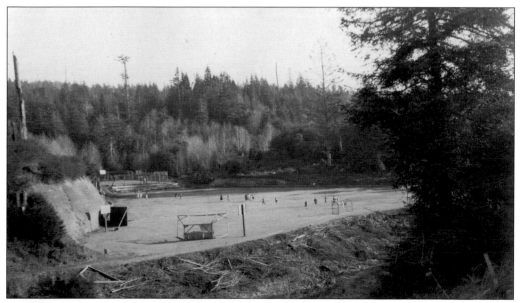

In 1936, the land that became Redwood Bowl was still an empty lot surrounded by snags. Football was played at Albee Stadium in Eureka. By the end of the 1930s, the college had a new gymnasium. Work Progress Administration crews doing community service helped create a football practice field covered in 6 inches of sawdust in this area.

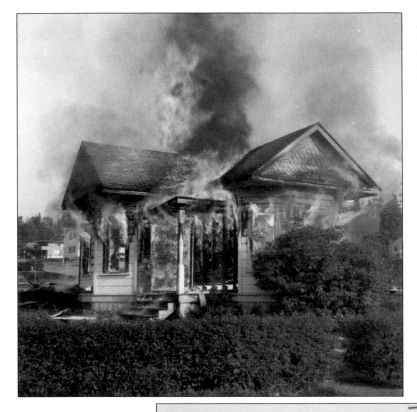

As Humboldt's campus expanded and more land was needed for building, a sturdy newer home might be picked up and moved, but an old one was just burned down. Years after this, in the 1950s, a house intended to be torched by the maintenance department went up in flames as a homecoming prank. The college administration was not amused.

The other option to burning a building in the way of expansion was to pick it up and move it to another vacant residential lot. The same pattern was followed during the freeway expansion of the 1970s. Then, several beautiful old houses were picked up out of the freeway's right of way and moved. Others were bulldozed.

The gleaming kitchen of Nelson Hall was in the only permanent dormitory on a state college campus in 1940. Built for $200,000, the hall is named in honor of Hans C. Nelson, whose legislation created Humboldt State Normal School. Nelson Hall's exterior architecture reflects Founders Hall and the College Elementary School's Spanish motif.

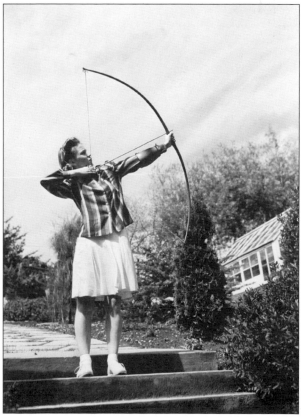

With transportation restrictions and gas rationing in World War II, intercollegiate sports events were difficult. In a women's archery tournament in 1944, the results were mailed to officials, and Humboldt placed fourth out of 24 colleges competing by mail. During the war, men's sports teams played servicemen at local military bases.

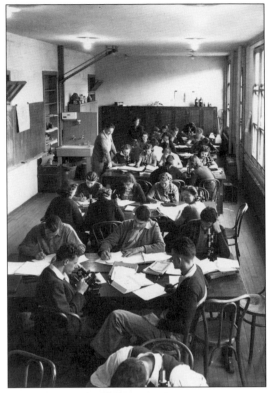

A botany lab is in progress in the basement of Founders Hall in 1939. The Forestry Club had organized the year before, and Humboldt was on its way to being a leader in environmental sciences. The second floor of today's university library has the Robert Paselk Scientific Instrument Museum and may include some of these antique microscopes.

The question 70 years after this photograph was taken is, Did Doris Gunderson, Henry Trione, and Rosie Ivansten ride the burro through the doorway and into Founders Hall? Everyone was dressed up for a barn dance day in 1939. Costume parties were popular social events.

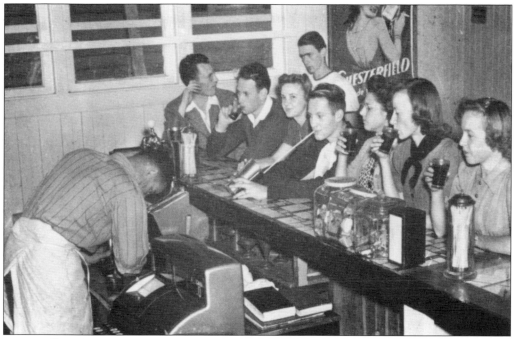

Every college had a place like Humboldt's Co-op (cooperative bookstore and fountain). A student could have a soda, chat with friends, pick up a textbook in the bookstore, discuss last week's football game, find a date for Saturday night, and forget about homework. The Co-op was originally part of campus housing. Called the "Little Apartments," the building was owned by Stella Little, who taught in the art department. It was remodeled in 1937 for student use and was replaced by the Student Union in the 1960s.

Waiting for mail to arrive or sunshine—something seldom seen but always appreciated by Humboldt students—brings "dormites" out onto the steps of a military-surplus barracks building being used as a dorm. Student housing was in short supply, and new, modern dorms named Redwood and Sunset halls didn't get built until 1959.

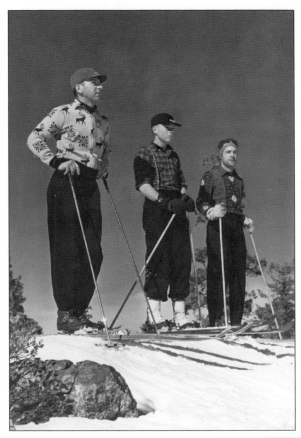

A ski club existed on campus dating back to 1939. With 60 members, not everyone knew how to ski, but they all knew how to have a good time. The Lumberjack Clubhouse cabin was 3 miles up Titlow Hill Road off Highway 299 on Horse Mountain. The ski club's February Snow Carnival was praised in the 1940 *Semprivirens* as a "tumbling success."

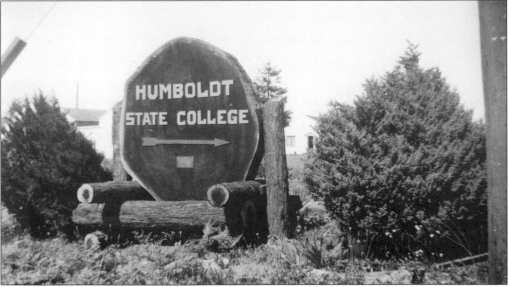

In recent years work has been done on signs to have a consistent appearance all over campus. In this earlier time, the HSC sign was on a round of redwood that was probably donated by a local lumber company. It told automobiles and students which direction to turn, plain and simple.

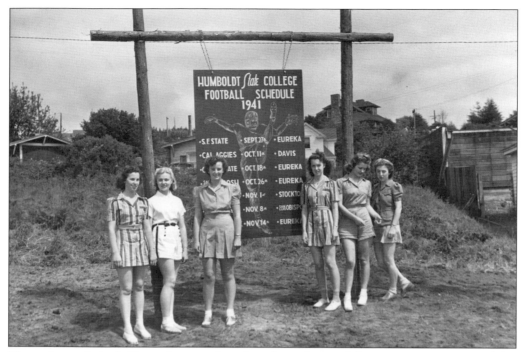

These six coeds, including twins, may have just cleaned around the sign on a campus workday when everyone pitched in to beautify the campus. The 1941 football season was a poor one, with two wins, five losses, and a tie. Planning was underway to develop a stadium behind Founders Hall.

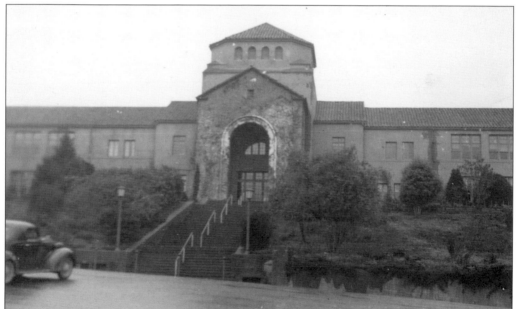

For a decade, ivy grew up the front of Founders Hall. Japanese submarines spotted off the coast during World War II prompted requests by local citizens to paint the building in camouflage so it wouldn't stand out against the forest. Spray-painted in the summer of 1944, all the ivy died, and it was 1949 before the building was painted a cream color again.

It's hard to visualize now that the campus was once forest, and after logging the virgin forest off, a lot of slash and stumps were left decades later. Before land could be built on or parking lots created, land clearing took place. This is the land just south of the College Elementary School.

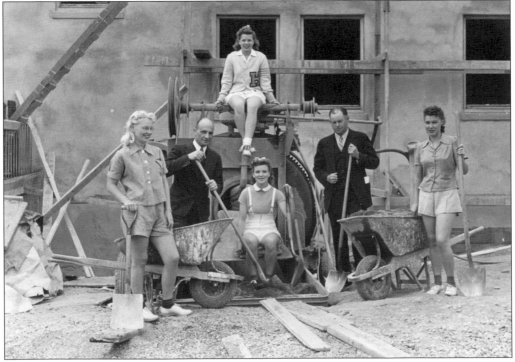

Work Day was initiated in 1925 as students and faculty skipped classes for a day and cleaned the campus buildings and grounds. Besides work, a faculty show, party, and dance were part of the day. This tradition endured until 1956. Those well-dressed administrators or professors are going to get dirty.

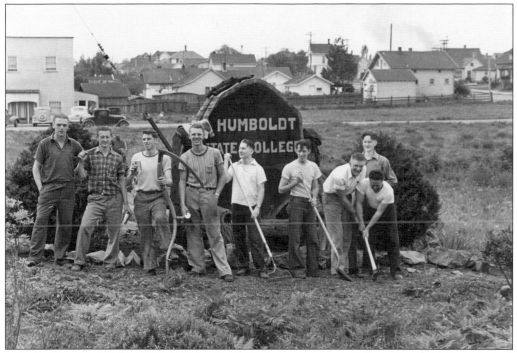

Work Days like this one in the 1940s meant no classes and fun. Students and faculty cleaned windows, removed clutter, weeded, repaired roads, cleaned classrooms, and enjoyed a free bean feed and a faculty show of spoofs and skits. The Work Day tradition endured for decades.

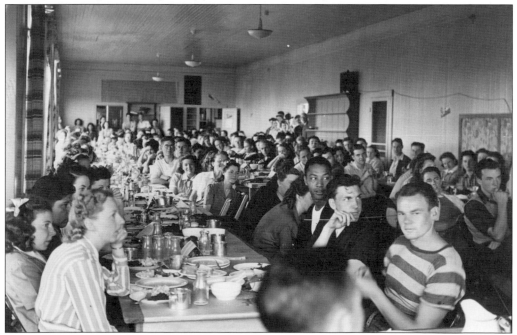

Students gather to eat and listen at what may have been a Work Day meal, perhaps in the temporary building next to Founders Hall. The informal small-town friendliness of the student body faded away as enrollment surged after World War II.

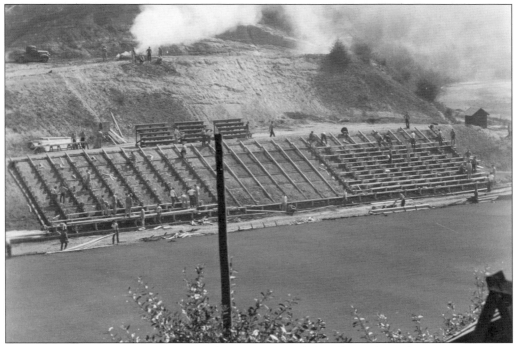

Some Work Day projects were bigger than others. Slash fires burn discards as new bleachers built with community support reach up the east side of Redwood Bowl. The 1947 events stretched to two days to get the project done. The name of the street that ran up towards Redwood Bowl in the 1940s was Willow Street; it is now gone forever under gym buildings. Seen below, students paint directions on the roadway directing traffic to the new stadium as a Work Day project.

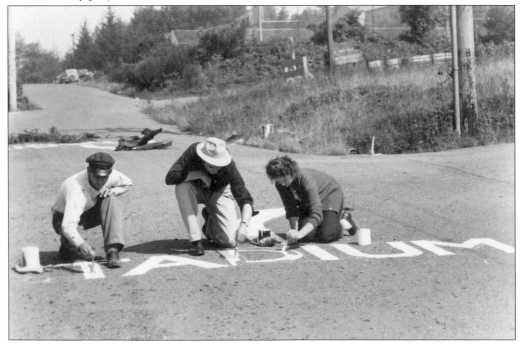

Joseph Forbes, the 1946 athletic director and football coach, stands by construction for Redwood Bowl. The bleachers in Redwood Bowl were built by students under the directions of local carpenters. The playing surface of the field was redwood chips over rocks to prevent injury to the players.

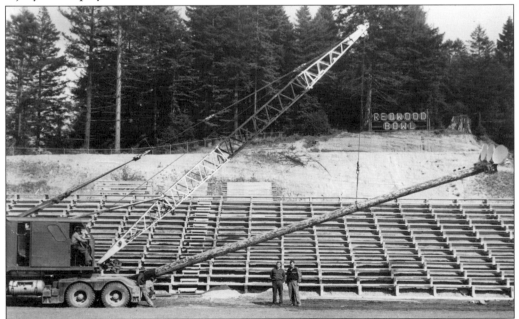

So many people went to football games on Saturday afternoons that the town merchants were losing business. Alumni helped pay $3,000 for lights and switches so games could be moved to evening. Poles were donated by local lumber companies, and loans were taken out to pay for the crane and operator. Student activity fees paid off the loans over several years.

Commando physical fitness replaced football after the start of World War II. Baseball coach Marty Mathiesen created an obstacle course around the playing field to prepare men for basic training exercises in the military. Sport competition during the war was limited due to the gas rationing, but the men still at Humboldt formed basketball teams to play military service teams from Orick, Eureka, and McKinleyville.

Veterans returned from World War II gather in front of Founders Hall in 1946. Many professors had also taken leave of absences to serve the nation in civilian and military capacities. Six units of credit for service during the war were given to veterans returning to campus. A new football coach, Joseph Forbes, was hired so football could resume in 1946.

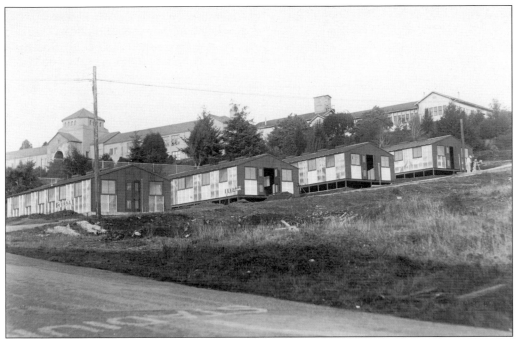

The end of World War II brought a surge of enrollment, and six temporary prefab buildings were placed where the art and music buildings stand today across from Jenkins Hall. Founders Hall graces the skyline with the original temporary building to its right in this 1946 photograph. The wildlife management and fisheries program began in one of these huts.

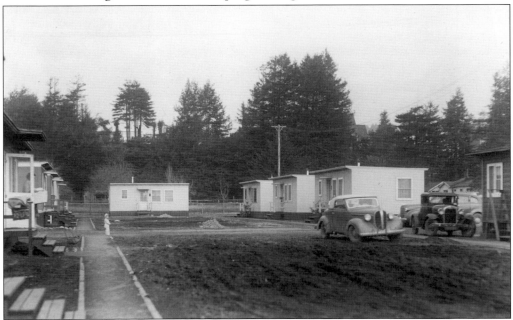

In 1946, this was called Humboldt Village, but it was nicknamed G.I. Village or the Mud Flats. The 30 units of former military housing for married students and vets were on land southwest of Gist Hall. The *Lumberjack* student newspaper reported 173 students living here in 1946. Temporary housing occupied this area for the next 39 years.

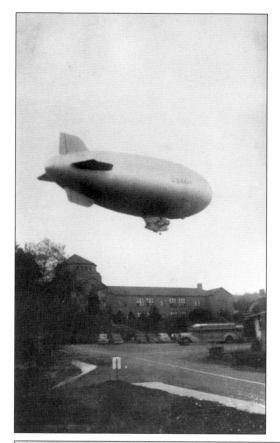

The military men at the World War II dirigible base across Humboldt Bay in the town of Samoa used to like to fly over the quad at Founders Hall to get the coeds to come out and wave at them. The motor noise reverberated in the quad to the irritation of professors and set every dog within blocks to howling.

A Quonset hut east of the original gym provided extra indoor space for physical education classes like boxing, archery, folk dance, and gymnastics after World War II. The new reserved seating in Redwood Bowl looks spiffy in this 1947 photograph. Founders Hall had yet to be repainted and still featured the dull colors used as camouflage during World War II. The hut was replaced by a swimming pool in 1957.

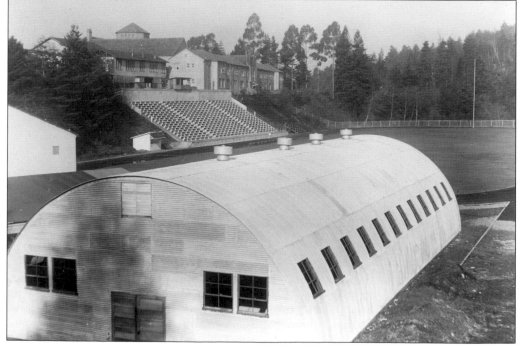

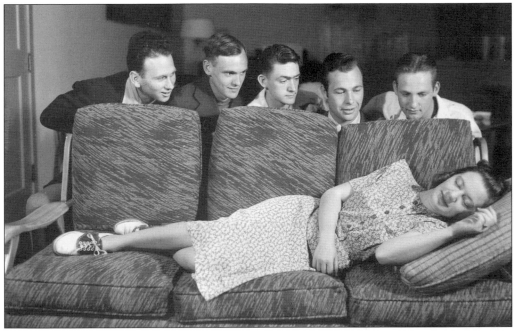

Though this was probably a drama production, the rapt attention of the men towards the pretty coed could have been a reflection of the postwar years, when men filled the campus studying forestry and wildlife and women were fewer in attendance. Girls wanting boyfriends had an abundance of men to choose from!

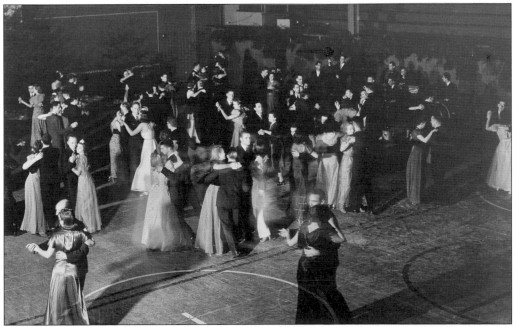

Couples whirled so quickly at this formal holiday dance in the gym that the camera equipment of the era could barely capture the image. Winter Sno-balls started in 1950, and Sweetheart and Harvest Balls were all former traditions, along with Homecoming dances, sock-hops, and bunny hops.

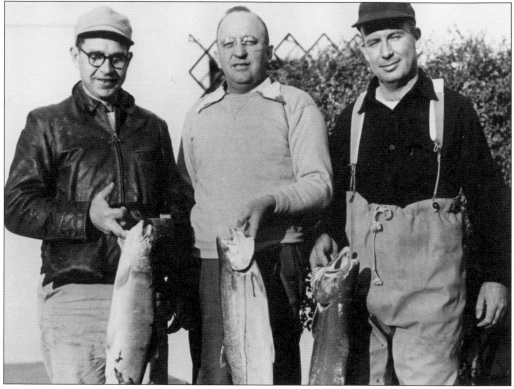

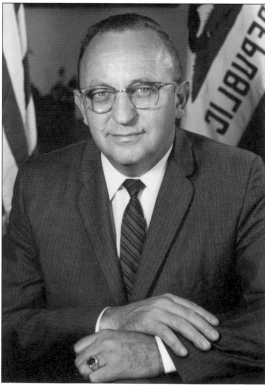

If college president Cornelius Siemens liked to fish, he had come to the right campus to find knowledgeable fishing guides. In 1953, he is flanked by two of the pioneer instructors in natural resources, Mark Rhea (left) and John Dewitt (right), and their salmon catch from a fishing trip.

Cornelius Siemens was the fourth Humboldt president, serving from 1950 to 1973.

Four

SIEMENS ERA
1950–1973

It was Humboldt's biggest expansion of growth ever, and for 23 years, Cornelius Siemens was in the midst of it as Humboldt's fourth president. Enrollment grew, faculty expanded, buildings sprouted up, and social behavior changed, and through it all, Siemens kept everything under control. With a doctorate from the University of California at Berkeley and years of teaching experience, he immediately immersed himself in challenges.

More than 30 buildings in use on the campus today were built during the Siemens era. Enrollment increased from 750 to over 6,000 students. Humboldt's reputation as the school to go to for study of the natural environment and its preservation was established in Siemens's era. Alternative ways of teaching were explored. In the turbulent years of the Vietnam War, Siemens won the respect of the students by supporting free expression of anti-war sentiments. Governor Reagan closed all of the colleges in the state for a week after the Cambodian Incursion in the spring of 1970. After a rally of 3,000 protestors in Sequoia Quad, this institution conducted a peaceful week of teach-ins while Siemens accompanied student leaders and faculty to Washington, D.C., to express the campus's commitment to stop all war and all violence.

The end of the draft in 1971 and 18-year-olds gaining the right to vote saw a move away from campus-centered activities and more participation in community concerns. Youth Educational Services and Big Brothers and Sisters took Humboldt's students off campus to deal with the unmet needs of local youth.

President Siemens must have smiled as 1970 found 10,000 applications for 1,600 slots for new students at Humboldt. He certainly smiled in 1972, as years of hard work with faculty and staff paid off in gaining university status for the institution and a fourth name change to California State University, Humboldt.

Some suggest that Humboldt today should be called "the Campus That Cornelius Built." He had a love for flowers and landscaping on campus. One should think of Cornelius Siemens while looking at the rhododendrons surrounding the administration building, Siemens Hall, which was named in his honor.

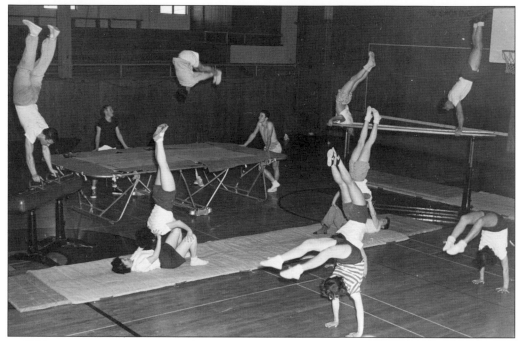

In 1959, gymnastics competition for men and women drew crowds to watch the exhibitions. Twelve campus athletes displayed acrobatic skills for the photographer. Photographs like this were featured in the *Semprivirens* yearbook. Gymnastic demonstrations were given at half time during Humboldt State College basketball games in 1954.

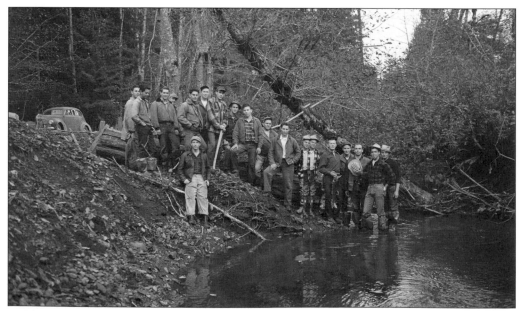

In 1954, members of the Conservation Unlimited Club took part in a stream clearance project on Grassy Creek. Courses in forestry and logging began in the 1930s. Humboldt often attracts more students to study forestry than other college programs due in part to the rich natural environment surrounding the campus.

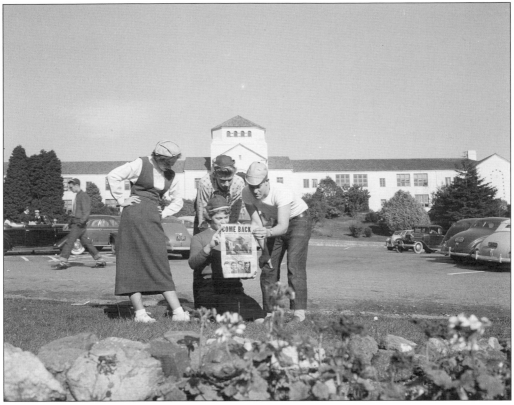

"Come Back for Homecoming 1952," the *Lumberjack* newspaper declares. Alumni did return for the game (usually against Chico State), dance, Alumni Banquet, parade, variety show, bonfire rally, and open house. From left to right, Pat Quackenbush, Nancy Earle, Tom Bascone, and Ed Solenberger check out the schedule of events at the fourth annual Homecoming.

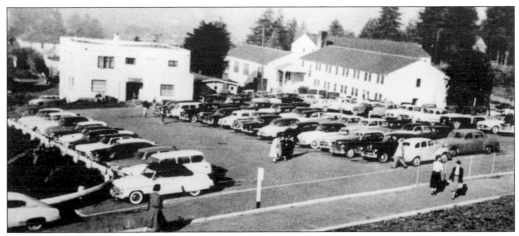

The Co-op was the place to go for food, books, and good cheer. It boasted that the dining area might have unrehearsed jitterbugging, rousing rallies, initiations, practical jokes, jazz sessions, straw fights, paper fights, and verbal fights, but never fist fights. This 1950s photograph shows the area now covered by Siemens Hall.

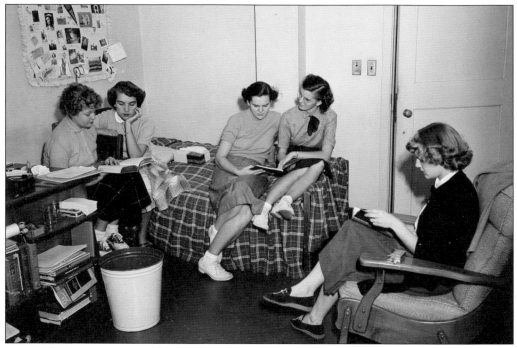

Dorm life 50 years ago still featured studying but pipe smoking is now banned. Nelson Hall had wings for men and women separated by a commons with a dining room and kitchen, an infirmary, and a reception room. It also had a "house mother" as a live-in chaperone. Quiet hours were enforced. Nelson Hall president Joan Palmer is on the far left with friends studying in 1952, and in 1953, Nelson Hall men Ed Solenberger, Dave Smith, Ed Conway, and Mike Cothern hit the books. Big social events were the Sweetheart and Harvest Balls. Ground was broken for two new dorms, Redwood and Sunset, in 1958.

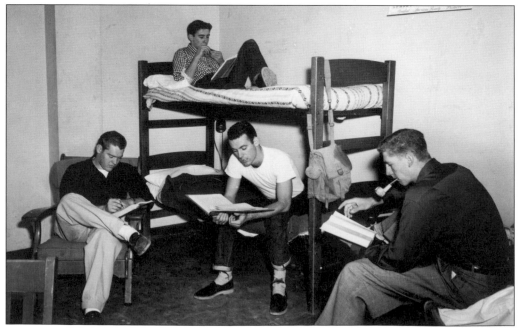

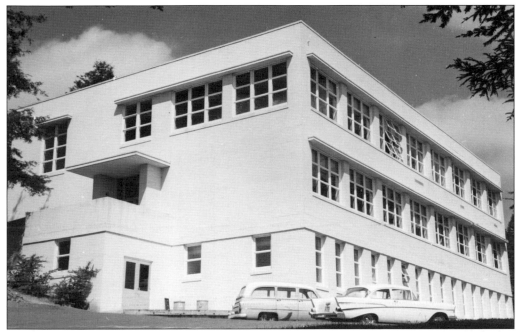

In 1952 this was the science building, new and shiny. By 2002, someone might ask which science building? Today science has a complex of five buildings and offers bachelor degrees in science education with a biology or geoscience emphasis for teachers headed to junior highs and high schools.

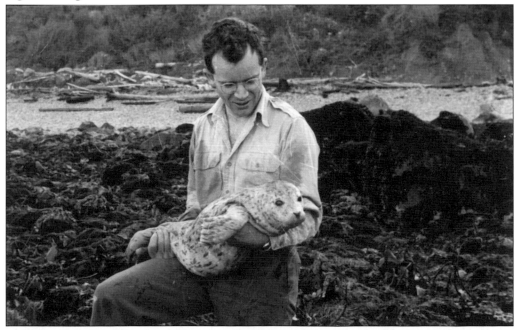

In 1953, senior life sciences major Leigh Manley studies a harbor seal pup at Abalone Beach near Patrick's Point north of Trinidad. President Siemens lobbied Sacramento for money for an ocean-going vessel for instructional purposes so that marine mammals could be studied from the ocean too. He got the money for the boat.

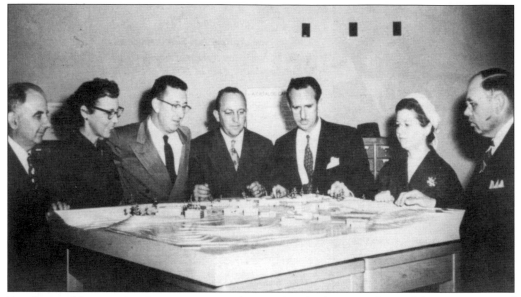

Faculty working on the Campus Master Plan in 1953 look at a scale model construction of what the future campus might look like. Suggestions in this master plan included three-story dorms east of Nelson Hall, a men's gym and swimming pool where Griffith Hall stands, a health center where the Forbes complex now sits, a chapel in the center of campus, and buildings east of Redwood Bowl, but plans got changed. Prof. Homer Balabanis (far left) earned the title "Mr. Humboldt" for more than 40 years of service and the art, music, and theater buildings are named the Balabanis Complex in his honor.

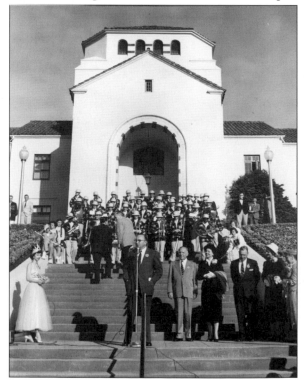

In 1956, what more could President Siemens (at the microphone) ask for? He's got California governor Goodwin Knight and his wife on his right, a homecoming queen on his left, the marching band behind him, and a parade ready to start.

In 1959, chemistry students, from left to right, Walter Harris, Beverly Batten, and Bonnie Montgomery look up from an experiment with a smile. Science students got a brand-new building in the expansion of the 1960s. Chemistry classes were required for future high school math and physical science teachers.

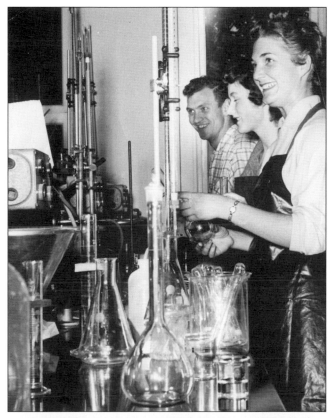

The plaid backwoods mackinaws and hard hats of the early 1950s marching band were abandoned for more conventional uniforms by 1959. By 1968, they added hardhats back and went on to become the Marching Lumberjacks. Learning to march and play in rainstorms was a necessity.

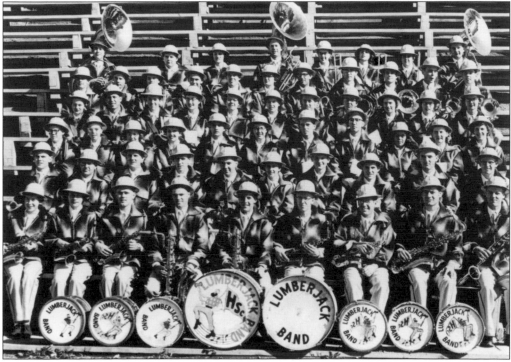

Local fish and game clubs in the early years supported courses in game management and conservation education. The first game pens were built where Redwood Hall is now with wood recycled from an old dorm that was torn down. In the summer of 1941, two hundred fifty day-old pheasants arrived, and later 475 game birds were released throughout the county for sportsmen. Jack Woody, Joe Harn, and Lloyd Clark raised these pheasants from eggs. It was the first college building in the United States designed exclusively for fish and game studies. Included in the project were a fish hatchery and ponds, game bird pens and brooders, a fur shed, and classroom space for 300. The photograph below shows the wildlife building under construction in 1955.

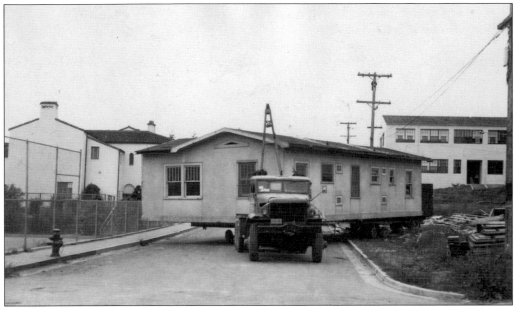

As another building is pulled away to make room for college expansion, Jenkins Hall is seen in the back to the right. Completed in 1950, it complemented the Spanish theme of other campus buildings. The industrial arts building was named in honor of H. R. "Pop" Jenkins, who began teaching in 1915. College Elementary School is on the left.

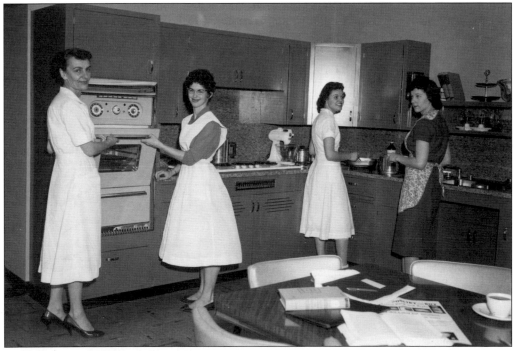

From left to right, Mary Farr is teaching Patty Span, Julia Burgess, and Karen Turner how to prepare a delicious chicken dinner in the Home Management Cottage in 1959. Home economics was considered an applied science and was taught until 1990, when its courses passed into the health, physical science, and child development programs.

Rally committee cheerleaders of the 1950s include, from left to right, Dick Nitsos, Donna Douglas, Tom Murdock, Loren Abbot, Jean Gowall, and Bob Maupin. It was an era of pep rallies and pom-pom girls. Cheerleaders vanished in the 1960s and reappeared in 1989, megaphones and all. The Marching Lumberjacks band members are modern-day cheerleaders.

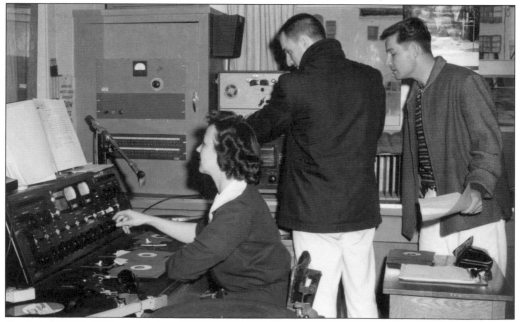

On October 17, 2009, KHSU-FM, the campus public radio station, celebrated its 50th anniversary. Since 1960, high atop the third floor of the theater arts building, it has been broadcasting music and community voices. The signal may not reach far, but the news and information are welcome. It was the first state college radio station in California and today has the highest internship on the north coast.

The Field House, under construction in 1961, casts shadows from the curved roof members over the construction site. Arriving from Southern California in 1967, the author had never seen a field with a roof over it before. After 30 inches of rain in a winter it's easy to understand the value of such a dry sports space. Today it is the site of the Student Recreation Center.

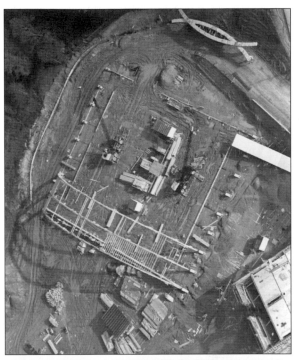

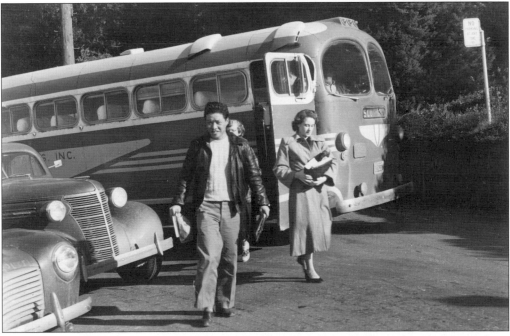

Metro Bus Service of Arcata started in 1962, offering rides from the post office to campus. Any Humboldt student who ever trudged from a downtown apartment to the top of Founders Hall with a heavy armload of books appreciates public transportation. Today's student fees help subsidize a mass transit system from Scotia in the south to Trinidad in the north bringing students to campus. Ride-sharing and bicycling are encouraged, as car parking is an eternal problem.

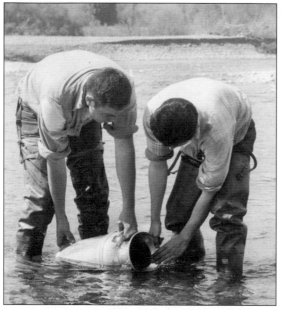

The fisheries program in 1951 improvised equipment, with a milk can from a dairy seen here. By 1956, headed by Charles Yocum, the college had an entire natural resources division offering bachelor of science and master of science degrees in fisheries and wildlife management. Humboldt has unparalleled access to freshwater and saltwater environments for fisheries studies.

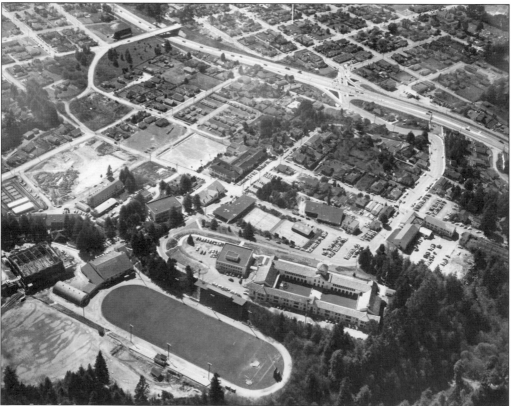

Looking west in the early 1960s, it's easy to envision the second building once planned for the parking lot next to the library (now Van Matre Hall) to the left of Founders Hall. It never got built, however. There were still empty lots and ample parking around campus, which is now all built up. The Field House was almost completed.

The Lucky Logger, the school mascot, may turn up in unusual places, but he is always waving. Based on a 9-foot statue that once stood in the men's gym, he has been a fixture on campus since 1952 and can scare the heck out of small children on occasion. The Lucky Logger gets to do all the fun stuff, like riding in a convertible in the 1962 Homecoming parade, attending games, going to dances, and representing the college on social occasions. It was considered a great honor to be the guy inside this costume, and the coeds loved to hug him and sit on his lap. The Lucky Logger is seen less on campus today but he's still around.

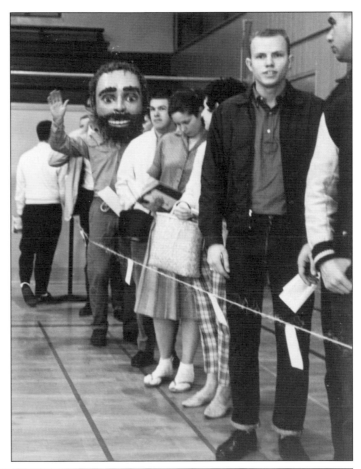

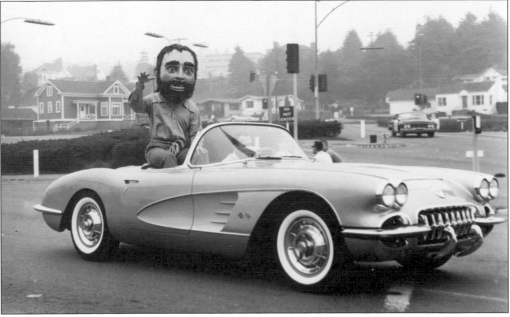

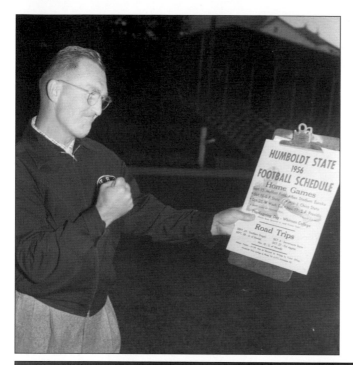

By the time Phil Sarboe retired, his football record over 14 years was 104 wins, 37 losses, and 5 ties. Football was Humboldt's most visible, successful, and entertaining extracurricular activity in this era. Sarboe coached in five Far Western Conference championships before retiring in 1966. In the 1956 season, notice on Sarboe's clipboard that his team won nine and lost two games.

Coach Phil Sarboe was one busy guy in the 1950s. He was a championship football coach from 1951 to 1965 who also coached baseball for two years, golf for five years, swimming in the 1960s, and a year of basketball. He was a contestant in the "Ugly Professor" competition of 1961 during Lumberjack Days.

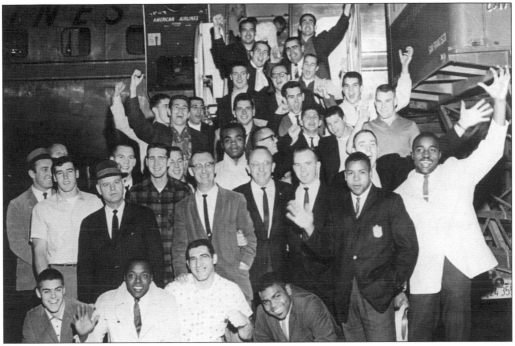

The football team's trip to the National Association of Intercollegiate Athletics Championship in 1960 brought segregation into local awareness, as Humboldt's black players were sent to "separate but equal" lodging and dining locations. The team knew beforehand this would occur but voted unanimously to compete anyway. They lost the Holiday Bowl game by a score of 15-14 in St. Petersburg, Florida. Below, coach-of-the-year Phil Sarboe cuts a celebratory cake with President Siemens on right watching. Lumberjack fans bought Sarboe a new car in tribute for his championship season.

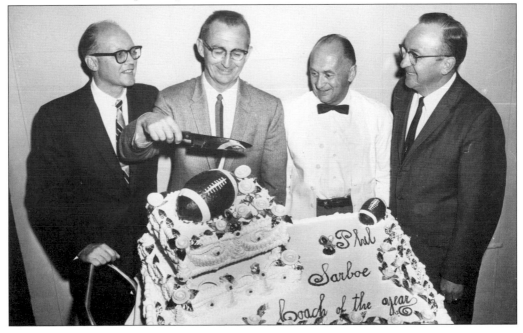

A crowd of summer school students and their kids enjoy a watermelon feed in 1960. Summer session has been offered since the 1920s, as teachers took classes to reinforce their skills in Humboldt's mild summer weather. The National Science Foundation sponsored classes many summers, the music department offered chamber music workshops, and sports camps for all ages occurred. It was also a great time for freshman orientation.

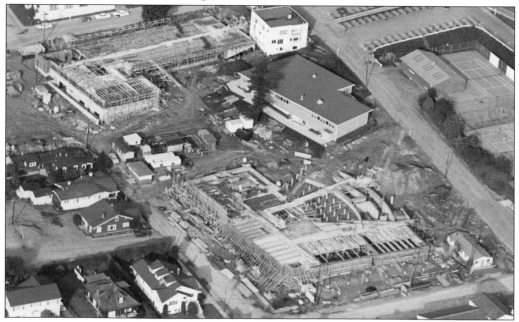

Fan-shaped Sequoia Theater (now Van Duzer Theater) and the new administration building above it were just part of the construction underway in the 1960s. Then new campus buildings went up in a short period of time. The Co-op, to the right of the administration building, survived as a student hangout until the new student union opened.

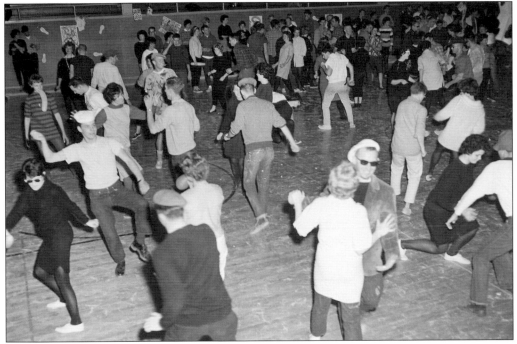

"Come on let's Twist again, like we did last summer. Let's Twist again, like we did last year. Do you remember," Chubby Checker sang. No matter what the dance step, Humboldt students and alumni remember dances in the gym. The music might change over the decades, but fond memories remain. Students came early to the gym dances to see how far they could slide on resin-coated floors.

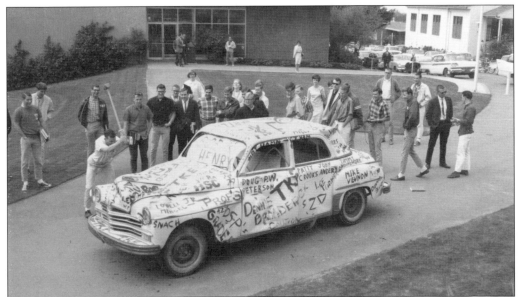

Car smashing was an event that let students whack out frustrations on an inanimate object. Students paid for the privilege to flail away on the dead car. Greek fraternity Tau Kappa Epsilon and sorority Delta Zeta have their names on this car in 1964 during what was probably a Lumberjack Day event.

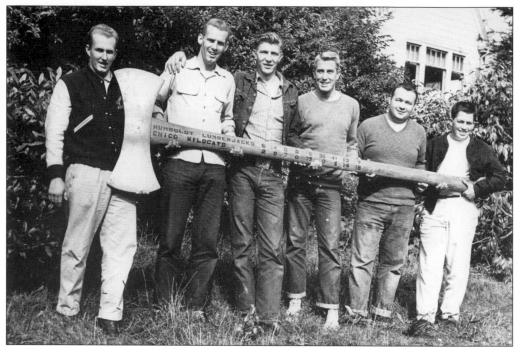

There are axes, and then there are really special axes. The first ax was made in industrial arts in 1948 to record the rivalry in football between Humboldt and Chico State. The game winner got possession of the ax to display for the year, then brought it back to the next game. Scores were recorded on the handle. When a new ax was needed, the Intercollegiate Knights had a new one made and presented it to President Siemens. The mystery is where that first ax disappeared to. The second ax is at Chico, since it was in that school's possession when Chico disbanded its football program.

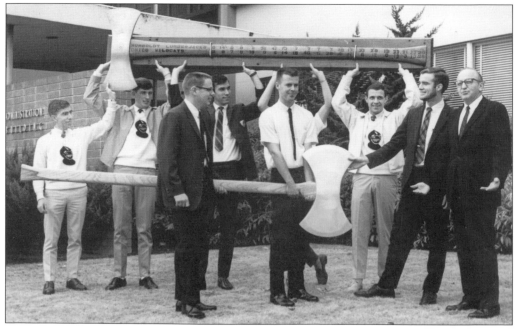

One of the most famous literary figures Humboldt ever produced was Raymond Carver, a short story writer. He was a struggling young writer with a family when he graduated in 1963, working dead-end jobs to make ends meet. He edited the creative writing magazine *Toyon*, and rumor persists that if he didn't like submissions he'd put in his own writing and attach pseudonyms to that work. He died in 1988 at age 50.

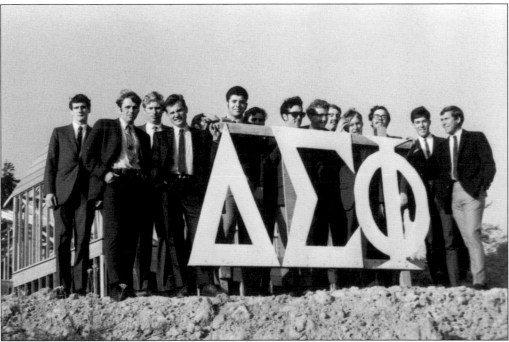

Delta Sigma Phi members surround their fraternity letters in front of a house under construction. Over the decades, Greek fraternities and sororities also included Tau Kappa Epsilon, Phi Mu, Delta Zeta, Delta Sigma Epsilon, Chi Phi, and Lambda Sigma Nu. Those groups active today are service or culturally based. It was once suggested in a Campus Master Plan that a Frat Row be built on Union Street.

The *Sea Gull* was the first in a long line of ocean research vessels owned by Humboldt. Serving from 1963 to 1968, she was followed by the *Catalyst* from 1971 to 1978. Also used were the *Malaguena* from 1969 to 1981, the *Pacific Hunter* in 1995 and 1996, and the *Coral Sea* from 1998 to present.

A memorial ceremony was held December 3, 1963, honoring the life of John F. Kennedy. Hundreds gathered to hear speakers and a band participate in a tribute to the slain president. The library in the background has been expanded so many times that it covers the parking area and ground where students stand here.

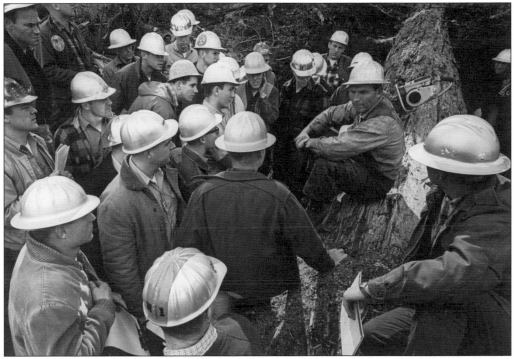

There are many ways to learn forestry practices, but sometimes going out into the woods and talking to the guys who are doing the work is most educational. Here students and instructor on a field trip talk with a timber faller and see the tree he just dropped.

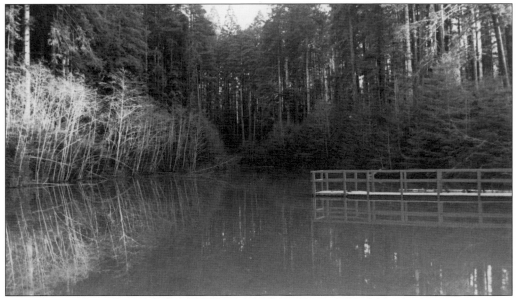

In 1938, instructor Hortense Lanphere proposed constructing a small dam on a little stream on the east side of the campus to divert water to a planned fish hatchery. The dam was improved several times, and the impounded waters became Fern Lake. The still waters reflect surrounding forest. Visitors look down on Fern Lake when they drive up to the Redwood Sciences Lab on Bay View Street.

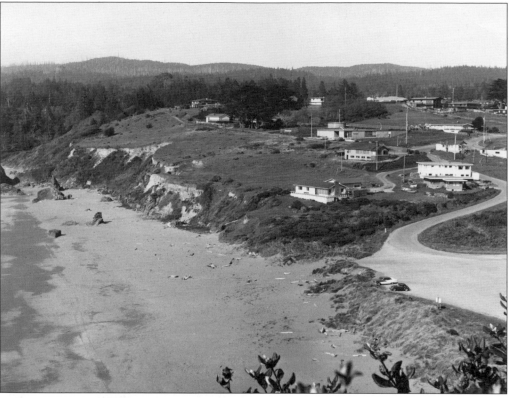

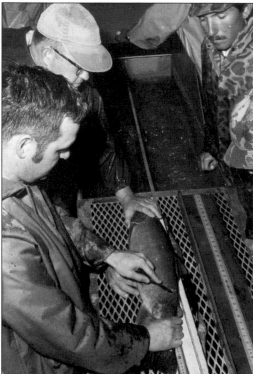

The Marine Lab in Trinidad was one of the Siemens administration's accomplishments. Eleven miles north of the Humboldt campus, students in fisheries biology, oceanography, geology, and biological sciences conduct research. The lab, built in 1966 and enlarged in 1979, features a circulating seawater system, lecture rooms, and research labs and is open to the public. Now the Telonicher Marine Lab, its name honors Fred Telonicher, who taught for 40 years.

What was created from a razed dormitory's lumber, four abandoned troughs, redwood shake bolts, and 10,400 salmon eggs? A fish hatchery on campus in 1939. Hortense Lanphere taught the first fish hatchery biology class in 1940, and ever since, students have been measuring and studying fish. Humboldt is one of a very few universities with an on-campus fish hatchery.

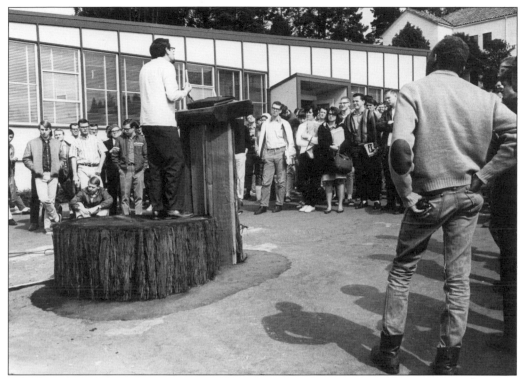

Whatever happened to the speaker's stump? A campus fixture in the 1960s, it allowed the Student Non-Violent Coordinating Committee's Jim Mendel to get up and speak his mind to the crowd in 1966. That same year, the students produced the infamous Faculty Register when students wrote reviews of the faculty and their skills.

Che Guevera, Jesus Christ, LBJ (on a motorcycle), Andy Warhol, Huey Newton, and psychedelic posters cover the walls of the author's Arcata home in 1968. Called the "Grey House" at 1811 F Street and the highway, it was an information center for the Peace and Freedom Party, a welfare rights organization, draft resistance counseling, and ecology preservation.

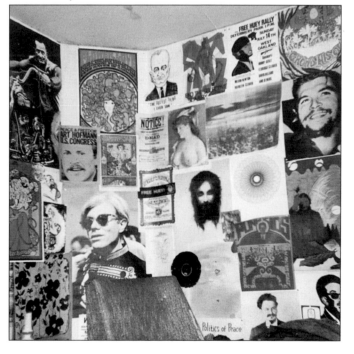

The Indian Teacher and Educational Personnel Program is over 40 years old now. These were the Native Americans in the first class in 1969. Begun to bolster Native American teachers in Northern California, it now provides curricular support and resources on, by, or about Native America. There are few programs like this in the western United States. Humboldt's Native American Studies major was the first of its kind in the state university system.

The newly completed $3.8-million Jolly Giant complex of dining facilities and eight residence halls three stories tall opened in March 1969 in a stand of redwoods at the north end of the campus. The commons building in the center fed 900 students a day from all the residence halls, including the older Redwood and Sunset Halls on the right.

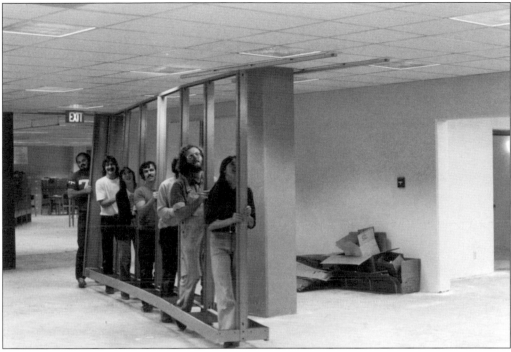

One of the unwritten rules of university libraries is that there is never enough space. When expansion or remodeling happens, every book must be picked up and moved repeatedly. The library began in Founders Hall's south end in 1922. It moved to a new building just to the south, today's Van Matre Hall, in 1953, then down to the center of campus in 1962 into a building three times bigger than its last home. Every remodel since then has increased its capacity around and above the 1962 structure. Today the structure holds half a million books and all forms of electronic resources. The Humboldt Room, a collection of the natural and cultural history of the area, seemingly has anything anyone has ever written on Humboldt in its collection and was the source of all the photographs in this book.

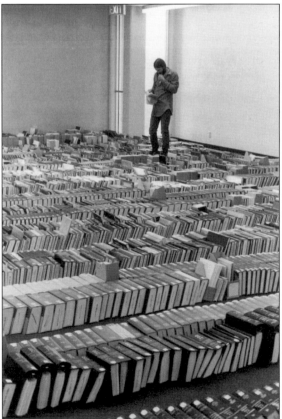

June 3, 1970

The following resolution was passed unanimously by the Academic Senate at Humboldt State College at the meeting of May 21, 1970:

RESOLUTION

IN BEHALF OF PEACE FOR ALL CREATURES --ESPECIALLY SWALLOWS--
OFFERED BY THE ACADEMIC SENATE OF HUMBOLDT STATE COLLEGE,
THIS 14th DAY OF MAY, A. D. 1970

WHEREAS, for the past several years a colony of cliff swallows (Petrochelidon pyrrhonota) has selected the hospitable eaves of the Humboldt State College Library for its breeding site after an arduous journey from the distant fastness of South America; and

WHEREAS, the peaceful inhabitants of this colony have attempted while here to bring forth progeny after their kind, in the way of all creatures; and

WHEREAS, forces inimical to birdlife have attempted to shatter the life, liberty, and pursuit of happiness of the aforesaid inhabitants by rude destruction of their nests even while they were at the very apogee of connubial felicity; and

WHEREAS, these forces have been at work for the past two years, continuing their work this year surreptitiously, under cover, and in the concealing darkness of the night; and

WHEREAS, we are now in a time of turmoil and tribulation, when it is most fittin we should strive for peace, not only between man and man but between man and all his fellow creatures, even unto the lowliest; and

WHEREAS, Humboldt State College is an institution devoted to the study of the aforesaid universal harmony between man and his environment, not only in the far reaches of the world but also in our own more humble precincts, and therefore it is of all places that where such harmony should be practiced and exemplified before the nation; and

WHEREAS, students, faculty and staff have recently given an outstanding example of peace and harmony in their own sphere of activities; now therefore be it

RESOLVED, that the aforementioned inimical forces at once, henceforth, and forever cease their catastrophic irruptions into the tranquility of our Avian cohabitants, so long as the redwoods shall stand and the Eel River flows to the sea; and be it further

RESOLVED, that this body will from this time forward constitute itself as a committee for the preservation and furtherance of the welfare of the inhabitants of said colony; and be it further

RESOLVED, that copies of this resolution be transmitted forthwith to the President, the Vice President for Administrative Affairs, the Business Manager, the College Librarian, and all Employees of the Maintenance Staff of this Colleg

Duly submitted by
Rudolf Becking
Charles Bloom

Society for the Welfare, Advancement, Learning,
Love, and Observation of the World's Swallows
(S.W.A.L.L.O.W.S.)

Every year, the swallows returned to nest under the eaves on the library building, and every year, the maintenance workers, doing their job, power-washed the nests down for sanitary purposes. Forestry professor Rudolph Becking and librarian Charles Bloom, on behalf of the Academic Senate, asked that this process stop. The landscaping on campus provided ample material for these nest-building swallows, and they really liked the library over any other structure to plaster nests on.

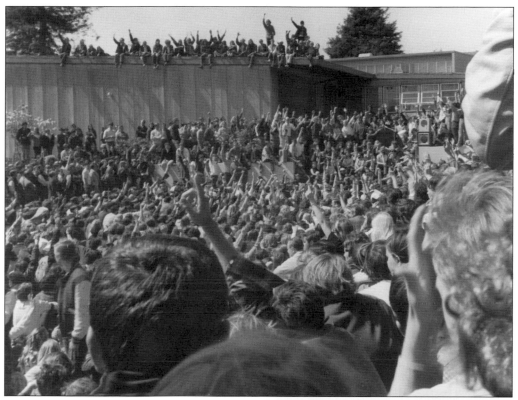

On campus on May 11, 1970, in the biggest single demonstration in Humboldt's history, 3,000 students and faculty voted for a voluntary peaceful one week "Strike for Peace" to protest the invasion of Cambodia and the prolonging of war in Southeast Asia. Governor Reagan closed all higher education campuses statewide to avoid violence for a week. Students went door-to-door to 8,000 homes in Arcata and local communities to explain why they were resisting the draft and protesting the war. Six hundred draft cards, discharge papers, and Reserve ID cards collected from Humboldt students, pictured in the photograph to the right, were sent to the Princeton Anti-Draft Center, where they were added to the thousands collected nationally and ceremoniously returned to the Washington, D.C. military draft headquarters. Remember that this was a time when an eligible man not in possession of his draft card was subject to a $10,000 fine and five years in jail. President Siemens won student respect for his support for the end of the war.

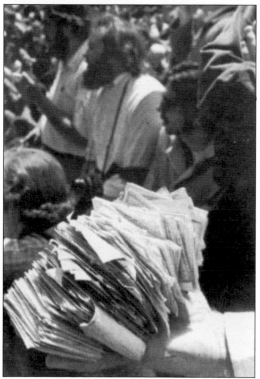

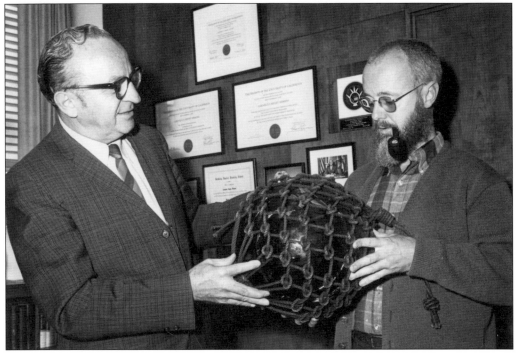

In 1970, Dr. James Gast (right) presented President Siemens with a Japanese glass float found while doing oceanographic research. Humboldt has had a half-dozen research vessels over the last 40 years, consisting of everything from fishing trawlers to ex–U.S. Coast Guard boats used by fisheries biology, oceanography, and wildlife classes.

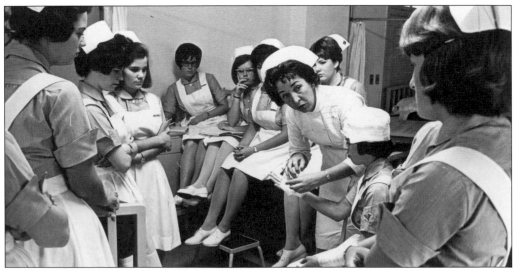

Pre-professional nursing classes had been offered since 1935, and in 1958, a nursing program began to create registered nurses. Transportation of nursing students to hospitals in Eureka and Arcata created difficulties, but by 1976, one hundred students were enrolled. The process to gain a place in the program is extremely competitive today.

Want other folks to go sailing with? Drag the boat out of the water, put it on the quad, and talk to other students about the idea. Big Lagoon, north of the campus up the coast, is a popular site for sailing, canoeing, and kayaking. In 1970, an Arcata dentist, Dr. Thomas Thomsen, donated a 13-foot fiberglass sailboat to start a campus club for sailing.

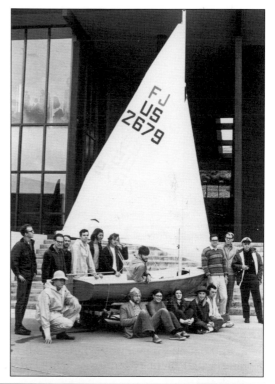

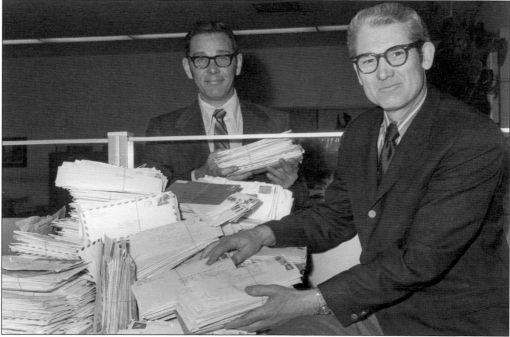

In 1970, administrative officers Robert Anderson and Don Clancy smile with delight at the 1,500 applications for fall quarter admission. By 1977, Humboldt students came from every county in California, 41 states, and 19 foreign nations, and there were over 7,000 students. After a drop to 5,800 students in 1986, enrollment grew again and is now about 8,000.

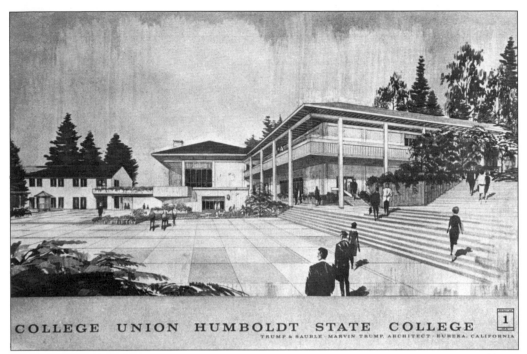

COLLEGE UNION HUMBOLDT STATE COLLEGE
TRUMP & SAUBLE · MARVIN TRUMP, ARCHITECT · EUREKA, CALIFORNIA

Ground was broken in 1971 for the College Union building. A $2.1-million project, it offered dining, recreation facilities, and a bookstore. Today the structure is called the University Center and features 54,000 square feet of space with conference rooms and lounges along with a bookstore and dining facilities. An elevator tower has been added.

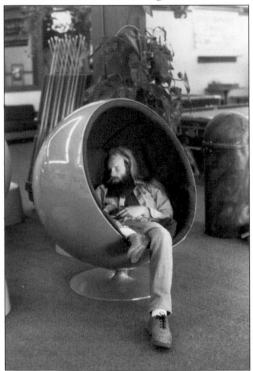

Next to the pool tables in the new College Union, the fun thing about these pod chairs was how many people could cram into one. Passersby would see a chair full of arms and legs protruding in several directions accompanied by giggling. They were also a great spots for a protected nap.

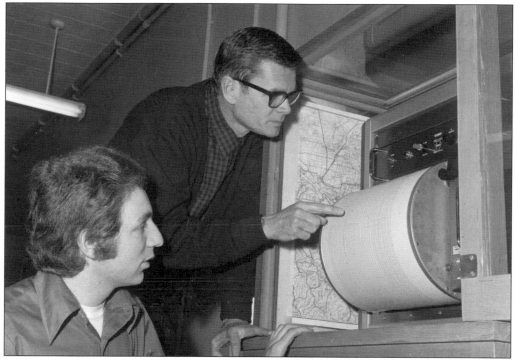

Here is a trivia question. Where is the seismograph on campus? While results print out today in Van Matre Hall, the machine itself is in a vault underground in the south end of Founders Hall. Geology professor Dr. John Young points out tracks on the visual recorder to technician Roy Kohl. In 1971, when Founders Hall was retrofitted, these instruments were deemed too delicate to move and were protected in place.

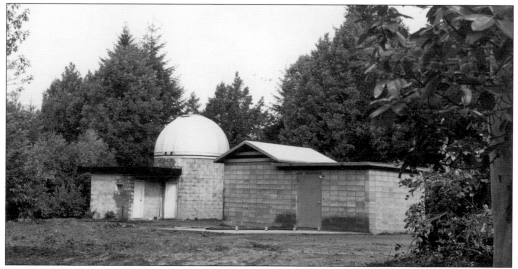

Humboldt's first observatory, 2,000 feet above sea level and 10 miles from campus on Fickle Hill Road, was dedicated in 1971 with a 12.5-inch reflecting telescope. The 60-acre site was donated by three alumni as part of the Astronomers of Humboldt County Club. Now two observatory buildings house two 14-inch telescopes and six smaller 8-inch telescopes with hands-on, state-of-the-art computer control and astrophotography capacity.

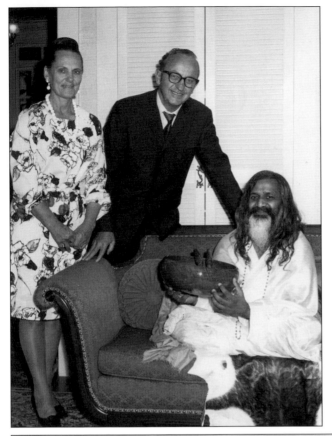

The Maharishi Mahesh Yogi, founder of the Transcendental Meditation movement, is presented with a carved redwood salad bowl and utensils as a gift by college president Siemens and his wife, Olga, in 1970. The maharishi directed a month-long teacher training course for 1,400 followers, and the campus cafeteria quickly adapted to vegetarian cuisine. Summer school that year had a whole different feel, as some very colorful characters roamed the campus. Below, the campus sponsors of the Student International Meditation Society (SIMS), which hosted the event, joined the spiritual leader. From left to right are Dr. Larry Squires and Dr. Seymour Migdal, Humboldt's SIMS advisors; Jerry Jarvis, director of SIMS; and Dr. Donald Strahan, vice president for Administrative Affairs at Humboldt State College.

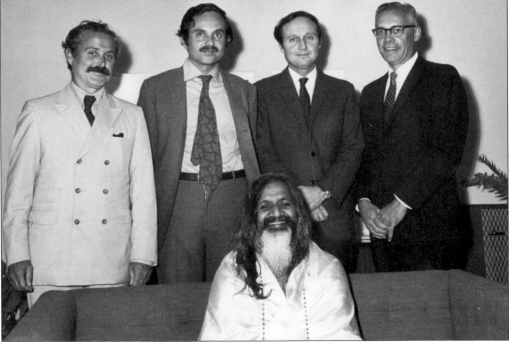

In 1952, the tower of Founders Hall held a Celesta Chime Carillon. The $1,300 instillation was paid for by donations from community groups like lumber companies, fraternal organizations, fur farms, doctors, livestock associations, labor unions, a Danish Ladies Club, and an ice cream company. By the early 1970s, the space had become the Kerr Meditation Tower, seen here. A new carillon now chimes from the top of the elevator tower at the University Center.

It's amazing that as many students ride bicycles as they do because any campus that features height and canyons in its place names promises an energetic workout for cyclists. There are 800 bike racks and designated lanes for riders, and bike maintenance workshops are offered. The county's Redwood Transit bus system accommodates bicycles.

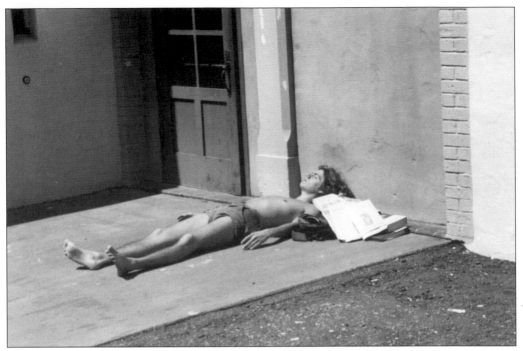

In a climate where 40 inches of rain a year is not considered unusual, a day of warm sunshine is something treasured and put to good use. Forget studying, forget socializing, forget responsibility, go out and soak up some rays. In the fall, weather can go from sunbathing warmth to storms overnight.

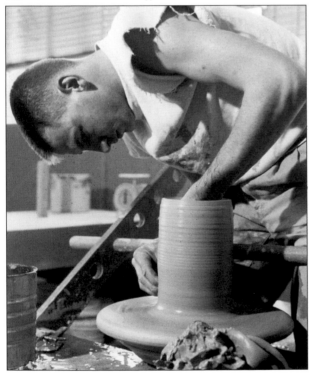

Reese Bullen, who taught ceramics for 20 years, inspired many students like this one, and a campus gallery bears his name. This may be a photograph by Prof. Tom Knight, who inspired other artistic students, including Bill Brazill, a 1970 grad, who, with others, later produced a book of Knight's work. Brazill became the high school art teacher in Mendocino who inspired the author's children in the 1990s.

The freeway expansion in the 1970s destroyed hundreds of student housing units. The author's rental, a beautiful old gray Victorian on the northeast corner of the old intersection, became a bulldozed memory. The university library is undergoing another expansion in this photograph. Student housing would expand along the road up Jolly Giant Canyon in the 1990s. The skinny white rectangles of single-wide trailers for student housing has been replaced now by the Lower Playing Field.

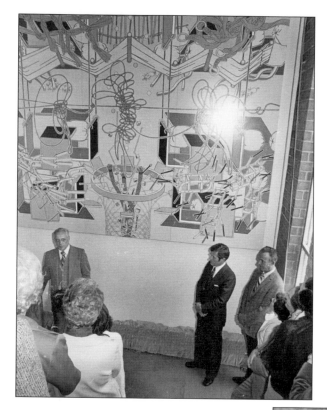

The Ed-Psych building was renamed Griffith Hall in honor of Harry Griffith, who taught from 1939 to 1966. A mural by art professor Glenn Berry decorates the wall. At the 1978 dedication ceremony were, from left to right, Donald Strahan, vice president of Administrative Affairs; Pres. Alistair McCrone; Glenn Berry; and Beverly Griffith, a nurse at the campus health center.

Alistair McCrone was the fifth Humboldt president, serving from 1973 to 2002.

Five

McCrone Decades
1973–2002

Humboldt's fifth president, Alistair McCrone, arrived in 1974. By training and education a geologist, he had served in various administrative capacities for universities around the United States. Strongly supporting liberal arts, he urged the faculty to work towards quality of education in a time of declining budgets.

Enrollment peaked at just over 7,000 students in 1972 and then dropped down to 5,800 by 1986. Many professors retired, and after 20 years on the quarter system Humboldt reverted to semester class scheduling. With tightening budgets, new campus construction was still undertaken. All-weather playing fields were installed, an engineering and biological sciences building was erected, and a geodesic greenhouse was built. Remodeling took place in Founders Hall, the health center, Gist Hall, the Marine Lab, the wildlife building, and the library. The Creekview Residence Halls were also constructed. There was growth in ethnic, women's, and Native American studies. Ecology and environment studies gathered more students. A national magazine recognized Humboldt as an institution "lesser known but of high quality," and the campus has appeared on nationwide best college lists ever since.

Women's sports blossomed and won recognition, and the wrestling team grapplers won eight conference championships. McCrone worked to enhance campus/community relations with projects like the Arcata Marsh enhancement, a distinguished lecture series, and a partnership campaign raising money for projects at Humboldt not funded by the state. The 1990s found the university struggling for funding for classes and faculty and with a housing crunch, but it persevered. McCrone remained busy delegating responsibilities, advocating for the scholarly and academic aspects of university life, and improving Humboldt's image and visibility in the community. From 1983 to 1993, alumni, parents, civic groups, and the community raised $1 million a year in annual financial donations to the university.

Alistair McCrone retired in 2002 proud that his university community was dedicated to the "Humboldt Spirit" of leaving the world in a condition worthy of life itself.

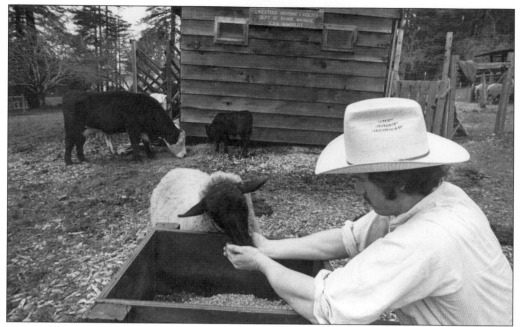

Humboldt is the only state university offering a bachelor of science degree in Rangeland Resources and Wildland Soils. In 1954, there were 1,240 dairies in Humboldt County, and livestock management has been taught for decades. The university provides a unique, valuable resource to the local agricultural community, encouraging students to study whole ecosystems.

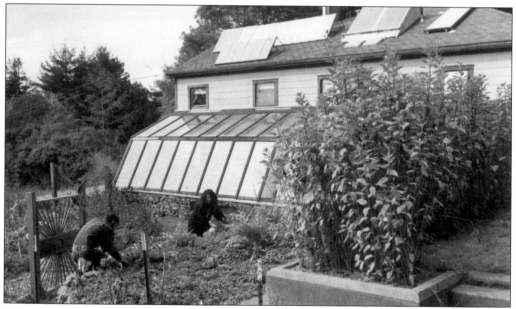

For 30 years, the Campus Center for Appropriate Technology (CCAT) has been a focus for sustainable living practices. An old house on campus was retrofitted for solar hot water and passive solar heating, gray-water recycling, and biodiesel production, and it features a greenhouse and gardens. In the path of new building construction, the CCAT House was picked up, moved, and later restored and reopened.

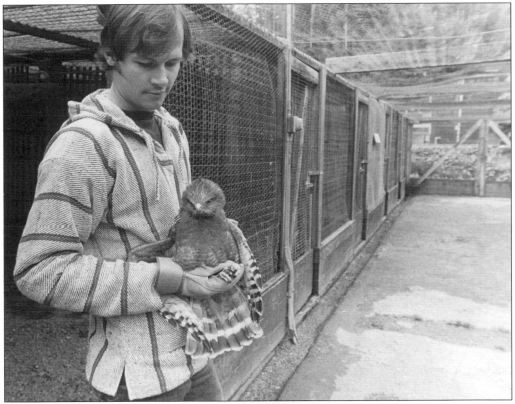

This area is referred to as the game pens, but the bird in question in this student's hands is a predator. Humboldt teaches ornithology, wildlife management, and many other classes to understand this bird's role in life in the wildlands. A huge flight cage at the game pens allows students first-hand observations of bird behavior.

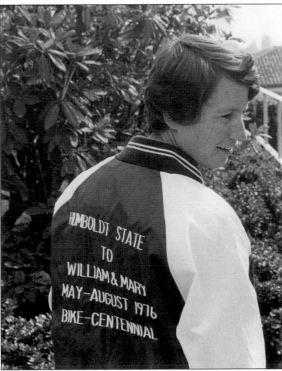

Charlotte Smith was a university employee with a 4,500-mile bicycle ride in front of her when she picked up a letter from Humboldt's president McCrone and arranged to deliver it to Thomas Grives, president of College of William and Mary back east. She did it and had all sorts of adventures along the way.

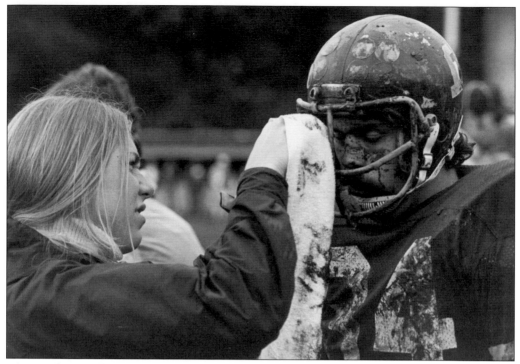

A bystander at a football game in 1977 finds a way to help the home team, cleaning the face of a muddy player. Many football games turned into slimy mud fests as Mother Nature made her liquid contributions to game day. Humboldt features "get wet" science and "get muddy" outdoor athletics in the fall.

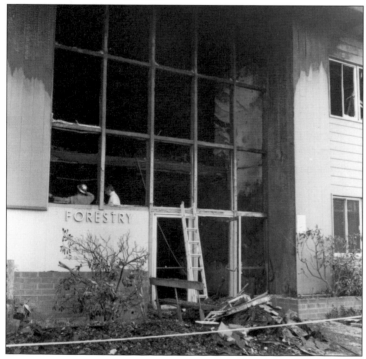

In January 1979, an arson fire damaged the forestry building, and it is an unsolved crime to this day. The building stood for 17 years, constructed in 1962 to showcase local hardwoods in the wall paneling. By October 1980, it had been rebuilt and reopened with the help of materials from local timber industries, and it was remodeled again in the 1990s.

In 1978, Cedar Hall dorm life had its funny moments. A crew of four men decorated paper-bag masks seasonally and gave female students candy treats—Halloween candy, candy canes, candy hearts, and Easter jelly beans. They were mystery masked men with treats. For 11 months they kept their identity hidden, but all secrets finally end. The women loved them. A Pizza Factory location on campus lead to dorm pizza parties on weekends, and liquor was legal in dorms for those over 21 years of age. Disco-dance dorm parties were popular then. These same young men were part of campus volunteer security teams that escorted women around campus during nighttime hours.

Humboldt professors have always been involved in "town and gown" activities with the local community, and this 1984 team of Humboldt State University (HSU) faculty basketball players probably would have played any team that showed up for a game.

Stairs twist along the side of the science building, where three species of redwood were planted, in 1981. The main campus has 107 plant families and 400 species in landscaping, making the grounds a botanical garden including 13 different rhododendron species.

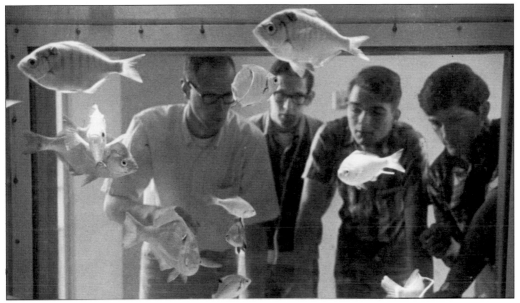

Seen through a fish tank in the Fred Telonicher Marine Lab, students inspect aquatic life. The Marine Lab opened in 1966 to provide oceanfront classrooms for instruction. The facility has grown and expanded, and visitors can still peer into aquariums. The lab was open weekdays and on weekends when Humboldt was in session in 2009. A solar hydrogen fuel cell system today powers the fish tank's air compressor.

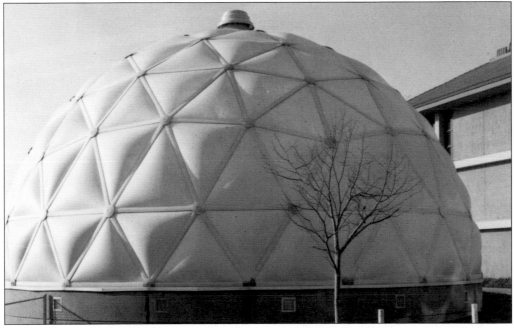

The 30-foot-tall geodesic dome greenhouse provided 10,000 square feet of space for desert, tropical, and aquatic plants in 1983. Humboldt now had the largest, most diverse greenhouse in the state university system with 1,000 species and 180 plant families growing. The university herbarium has 190,000 specimens. The greenhouse facility has rooms for desert, tropical, and crop plants, and a fern room.

It's 1986, and the student didn't think it looked like a rainy day when she left the dorm in sandals and without a hat or umbrella. Humboldt students quickly learn all the snappy comebacks to sarcastic comments about eternal rains. "No, I don't have moss growing in my beard" and "Yes, I LOVE liquid sunshine" are appropriate.

It doesn't rain forever, it just seems that way at times. Entryways to classroom buildings sprout dripping umbrella forests and the sound of squishing soggy footwear is heard. Bike riding demands new skills to avoid skids and slides. In better weather, there are tales of monumental bike rides from Founders Hall to the Plaza in Arcata, coasting the entire distance without ever pushing a pedal.

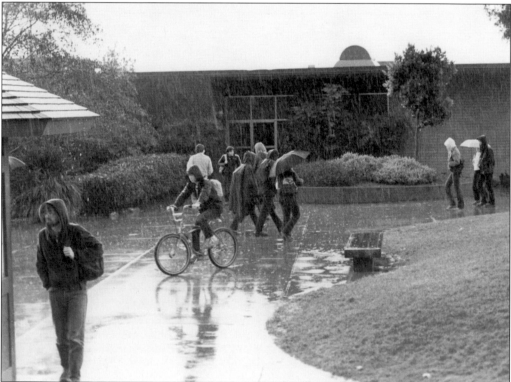

ARE YOU A HUMBOLDT HONEY?

Bobby McGee's dirty red bandanna

Question Authority

No Nukes T-shirt

Handcrafted earrings made from genuine porcupine quill

Peace sign with Taoist symbol of the yin and yang

Rolling Stone magazine

Mother Earth News magazine

Emergency bandanna

Greenpeace, Environmental organization dedicated to saving the whales etc.

All bio-degradable

Mother Jones magazine

Karma Cola

The Electric Kool-Aid Acid Test

Cannabis Sativa Indica

Bag of granola (essential)

Backpack for carrying miscellaneous items such as Mu Zest herbal tea, drawing pad and art supplies, Patchouli fragrance, the writings of John Muir, a book of poetry, an umbrella, a frisbee, a bottle of Ginseng-Up and incense

Stash bag for carrying a hacky-sack and liberty caps

CO-OP Community owned natural food store button

Tapestry skirt

Grateful Dead sticker purchased at annual New Year's Eve concert

Hairy legs under legwarmers

Birkenstocks - the sole of Humboldt County

100% wool socks (undyed)

A Humboldt Honey is a peaceful, free spirit who is in tune with the earth. She never wears makeup (it's unnatural). She likes the simple things in life such as love, peace and flowers. She can be found dancing to reggae music or listening to the Grateful Dead. She believes in a natural, holistic approach to health. She shops at the CO-OP for such things as tofu, sunflower seeds and sprouts. Organic (not to be confused with inorganic) fruits and vegetables are her favorite so she is frequently spotted at the produce aisle where the barefoot rastafarian sometimes plays his flute. She fights for organizations and causes such as Greenpeace and Save the Seals. She believes that solar energy is better than nuclear power, thinks Watt is not where it's at, agrees that Indian burial grounds should be kept sacred and that Virgil Payne was a good man. Her friends play Humboldt County sports like hacky-sack and ultimate frisbee. They often recite poetry to one another, discuss Zen, Taoism and Gandhi's philosophy of non-violence. Her message for everyone is a simple one of peace, happiness and above all, love.

Meet the Humboldt Honey of 1983. She was the poster child for the hippie world in the 1980s. She had everything a hippie chick needed; a bandana, protest buttons, a backpack for books and a bag of granola, reading material under her arm, a marijuana doobie ready to light, an ethnic skirt, Birkenstock sandals and wool socks, and the Humboldt weather essential—warm leggings. She's the girl you would find at the Arcata Co-op buying organic food and hoping the world would find peace, love, and happiness. In real life, the Humboldt Honey was the brainchild of Ingrid da Silva Hart, a journalism student in 1983. The idea was to make a poster that would capture the Humboldt "look," sell it, and help pay Hart's tuition. The model was Leoni Nico, a Scottish world traveler Hart found at the Co-op while looking for a model. The photographer was Patrick Cudahy. The finished poster, when distributed, created a minor uproar, with folks either falling in love with her or calling her a dour denizen of the dumpsters.

Every time it snows—about once a decade—it's photo opportunity time, and this man isn't letting a few inches of slush interfere with physical fitness. In 1989, snowfall closed the campus for four days as 7 inches of snow fell in February. It's a safe bet that someone was building a snowman at the dorms. In an earlier snow scene from decades ago, the nighttime lighting looks star-like as snows cover the campus. Snow just before Christmas vacation was always a treat, because it made it more fun for students to go out caroling, but it didn't happen very often. Whenever it snowed, the photographs ended up in the *Semprivirens* yearbook.

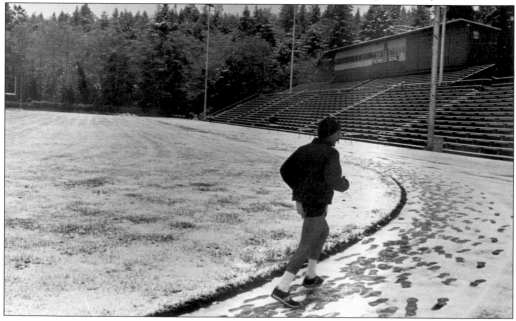

A young client has the attention of a member of the Speech and Hearing Center on the first floor of Gist Hall's west wing in 1983. The center dealt with speech pathology and auditory disabilities. Humboldt students could gain actual hands-on experience working with clients with communicative disorders under staff supervision.

The Friendship MacIntosh Computer lab was funded in part by the HSU Parent Fund Drive and had 25 stations. Apple, IBM, and Sun Microsystems all later donated computer labs after 1986. IBM punch cards were used for registration starting in 1958, and computerized registration by administrators began in 1968.

No, the photograph isn't upside down. This is a ring-tailed cat (*Bassaricus astutus*) hanging from the top of an observation cage. Little was known of the omnivorous, nocturnal forest creatures until alumnus Richard Callas studied them in 1983. Now a protected species, they were once tamed by miners to catch mice in their cabins. Though called cats, the creatures are related to raccoons and have a pointed fox-like face. They have semi-retractable claws good for climbing. They prey by pouncing on small mammals, birds, and insects, but will eat berries too. Ringtails squeak, chitter, grunt, growl, and hiss, and can live 8 to 14 years. These critters live in coniferous forests in Oregon and California and also in deserts and canyons throughout the Southwest.

Humboldt's drama performances have been growing since the 1920s and have always received strong community support. In 1987, grad student Micki Goldthorpe presented *Conversations of My Mothers*, her own composition. A transformational play, it had five stories going on simultaneously, with five women of different generations in different places building a production together.

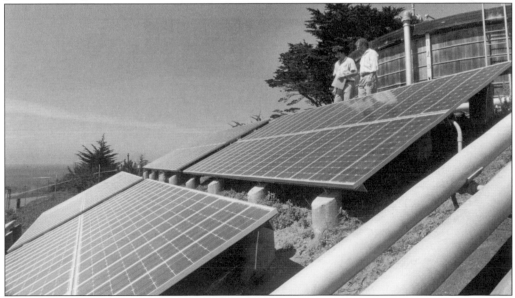

Some of the first solar panels at HSU appeared at the Fred Telonicher Marine Lab in Trinidad. Here in 1990, environmental resources engineering professor Peter Lehman and an associate look over 192 panels supplying electricity to the lab. Industrialist Louis Schatz, a longtime supporter of the university, gave $760,000 for an innovative research project converting sunlight into hydrogen gas and, through fuel cells, into electricity.

Humboldt's reputation for being a showcase for sustainability goes back decades. Here human-powered vehicles called ecocycles gather recyclables on campus. In the early 1990s there was 45 percent waste diversion recycling; now it's more than 60 percent. The California Integrated Waste Management Board uses Humboldt as a model for other state university campuses, as these institutions were the largest generators of waste in the state at one time.

In a scene that might have scandalized an earlier generation of students, a male and female student visit in a dorm room on campus. Dormitories at Humboldt went coed in 1969. While study aides, sports equipment, and style of dress may have changed, the forested view out the window remains the same.

The Mamas and the Papas sang "Young girls are coming to the canyon," and it's up and down into Jolly Giant Canyon students climb as they go to Laurel, Juniper, Willow, Fern, Pepperwood, Tan Oak, Maple, Madrone, Hemlock, Alder, Cedar, or Cypress dorm. Humboldt's Plant Operations department states there are 4,167 exterior steps on campus.

Art students take advantage of a sunny day to practice their craft outside with the attention of onlookers. Humboldt has long had an acclaimed art program, and exhibition space for student artwork is found in the Reese Bullen Gallery on campus and the university-supported First Street Gallery in Eureka's Old Town.

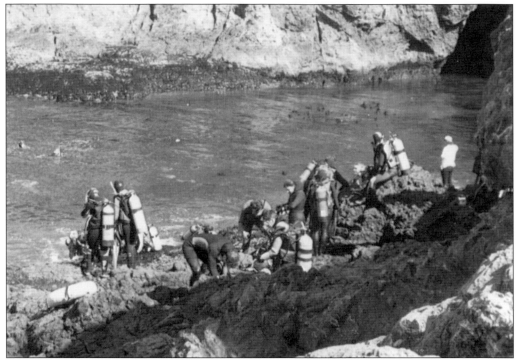

In 1995, these students could be studying oceanography, biology, geology, photography, or any area of sub-aquatic research, but they can use the skills obtained in Humboldt's physical education classes in scuba diving. Diving was offered as a minor with a physical education major. In 2007, more than 5,000 students signed petitions to keep diving classes in the curriculum.

Call it industrial technology or applied technology—it's figuring out how things work, how to make them, and how to fix and improve them. Unless one is working on a computer design for something new, one may be following the traditional path and end up getting dirty and greasy. Here students investigate an engine block.

Geology and anthropology studies overlap when obsidian and its properties are investigated as source material for the native artifact sitting on the notebook. Obsidian is not found locally, but by study of its composition, its origin and the natives who traded it to the coastal tribes can be traced.

This Yurok dugout canoe, now on display in the library, was a project of the Multicultural Heritage Program in 1990. Crafted by master boat maker George Blake and apprentices, the log was donated by Redwood National Park. Lightly burned out after carving to seal the wood, it had a heart knob inside, a Native American tradition.

Lumberjack Days started as a gathering of forestry students competing in traditional logging skills. It became a decades-long tradition when it replaced the All College Picnic in 1959, and it was traditionally a major fund-raising event for campus clubs that sponsored booths and activities. It was modeled after Chico State's Pioneers Day Celebration.

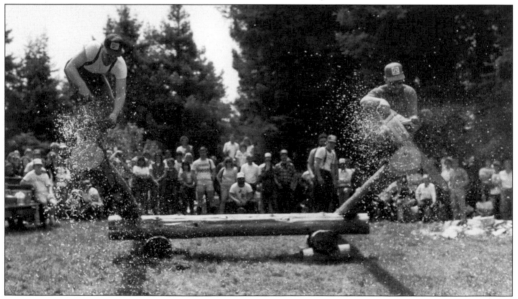

Contests for Lumberjack Days included traditional events like "Bull of the Woods," single-bucking, double-bucking, ax-throwing, chopping, and log-rolling. Here in 1983, forestry seniors demonstrate double-bucking. Lumberjack Days was seen by professors as a way to let students let off steam at the end of the semester.

Not every contest during Lumberjack Days required professional skills. Here contestants in a wheelbarrow race rush by viewers. A "Toss an Egg at Your Professor" booth was popular, as was rolling pin throwing for women, pancake flipping races, and canoe jousting on Fern Lake. With conversion from a quarter system back to a semester system in 1986, it became a fall event.

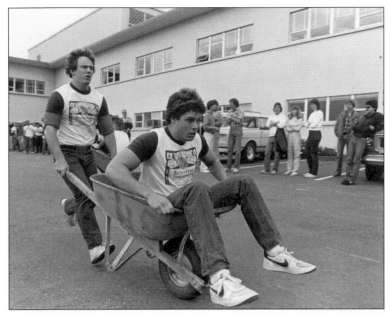

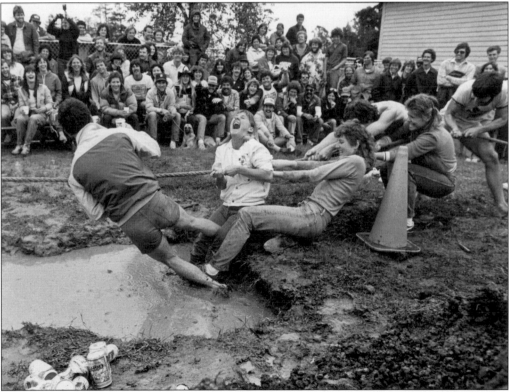

A messy, muddy climax to a tug-of-war during Lumberjack Days is about to occur. The beer cans visible led to the demise of the celebration. After problems with alcohol in 1992, drinking was banned, and students stopped coming. Today the Renewable Energy Fair and Art and Music Festival have replaced it. A solar-powered stage centered the fair in 2002, when over 6,000 visitors came.

Humboldt's Calypso Band was created by music professor Dr. Eugene Novotney in 1986 to showcase the traditional and contemporary music of the Caribbean, Africa, Brazil, and the United States. The band celebrates accurate and authentic connections to the roots of the steel band movement and the innovative musicians of Trinidad, where this unique percussion phenomenon was born. In 1998, the 25 members played drums of every size and range. Catch them on the Internet!

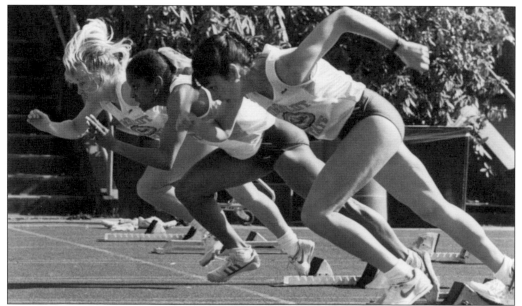

Women's athletics today include intercollegiate teams in soccer, volleyball, cross-country, basketball, softball, track and field, and crew, with club sports including rugby and lacrosse. Men field teams in football, soccer, baseball, cross-country, and track and field. The university also offers aquatic and dance classes and individual fitness activities.

Phone and computer technology have changed, but the busy activity inside the offices of the student-run *Lumberjack* newspaper never varies. Skills in gathering news, interpreting it, and meeting deadlines are always useful. The author of this book is a proud graduate of this program in the class of 1970.

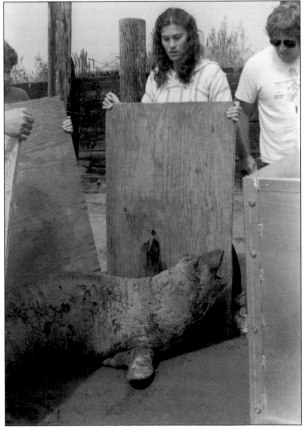

Marine mammals cannot be picked up and moved easily, but with a little creativity, students can aim them in the right direction. Humboldt's Marine Wildlife Care Center serves as a training and rescue center for birds injured in oil spills on the coast from Point Arena to Oregon.

There was a time when getting around Humboldt in a wheelchair was difficult, if not impossible, but today, the Student Disability Resource Center has helped make the campus accessible to everyone. There are now vehicle shuttles for the mobility impaired, sign language interpreters, assistive technologies in the computer labs, and a wide range of other services available. Adapting old buildings to meet Americans with Disabilities Act standards is difficult and expensive. Humboldt's terrain is a challenge. Today a concrete switchback path leads from the third floor of the University Center up to Founders Hall. Humboldt is on its way to becoming a barrier-free campus.

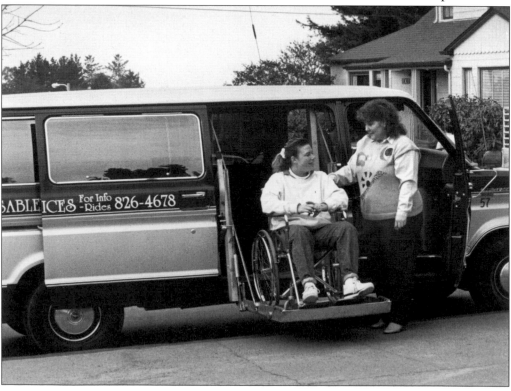

Biology professor Jack Yarnell set up his 65-foot hot-air balloon on campus for a visiting class of preschoolers in the late 1980s. It was his way of getting students of all ages excited about learning science. Short controlled ascents for little kids, teachers, and interested bystanders ensued. The engineering and biological sciences building in the background opened in 1982.

A curtain call takes place after a dance/physical theater performance in Humboldt's Van Duzer Theatre. Dance courses from the Departments of Kinesiology and Recreation and Theatre, Film, and Dance create an interdisciplinary major in Dance Studies. Students learn to transform thought into expressive movements in nonverbal communication. Students can focus on dance as language and culture, as an arts integration method, or as sacred tradition.

The inauguration of a new college president is a solemn ceremony with pomp, circumstance, and dignity. The last thing expected would be an impromptu appearance and performance by the Marching Lumberjacks Band, momentarily disrupting proceedings. Pres. Rollin Richmond took the interruption and presentation of a Marching Lumberjacks hard hat with humor during the ceremony on May 2, 2003.

Rollin Richmond is the sixth Humboldt president, serving from 2002 to the present.

Six

RICHMOND INTO THE FUTURE
2002–PRESENT

Rollin Richmond, the sixth president at Humboldt, arrived in 2002 promising to work together with students, faculty, and community to make Humboldt what "we want the university to become." Campus priorities include being student-centered, promoting diversity, practicing social and environmental responsibility, being involved with the community, and promoting economic development. Richmond is proud that Humboldt again in 2009 received *Princeton Review*'s "Best in the West" designation for regional schools.

Achievements include establishment of the Klamath Watershed Institute and the California Center for Rural Policies, which have brought research funds to the campus and opportunity for students and faculty to work on problems of significance to the region. President Richmond also oversaw the construction of a new Behavioral and Social Sciences Building, a five-story classroom that was the first LEED (Leadership in Energy and Environmental Design) gold-certified building in the California State University system. Other building projects under Richmond include the Kinesiology and Athletics facility and new campus housing for 430 students. Hands-on learning and involvement in campus life are important aspects of the student experience at Humboldt, and many efforts are focused on sustainability. President Richmond worked closely with students to create the Humboldt Energy Independence Fund, which uses student-approved fees for energy-efficient projects on campus. An on-campus hydrogen fueling station inspired by a design by a group of engineering students opened in 2008 and supports a hydrogen-powered car. It is the only rural site on the state's Hydrogen Highway system.

From humble beginnings in 1913 through five name changes to the institution it is today, Humboldt has grown and prospered. By 2009, the main Humboldt campus covered over 150 acres, and multiple off-campus facilities include a marine lab, astronomical observatory, and demonstration tree forest. Nearly 8,000 students study with 500 instructors and can choose from more than 47 majors and 80 minors. Twelve athletic teams compete and 180 clubs offer leisure activities, with Mother Nature providing the playground. The past has been fascinating, and the future looks good.

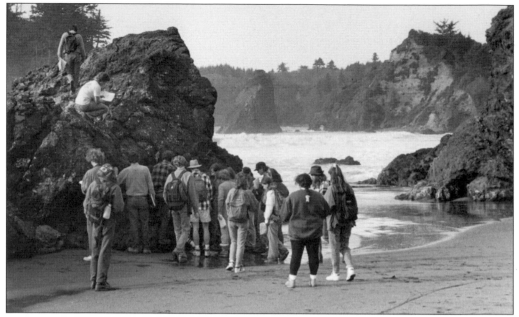

When exploring the photographic archives of the Humboldt Room in the library, viewers can find photographs of field trips to the beach going back 70 years or more. It could be a geology class or an oceanography class or marine biology, but whatever it is, students here enjoy the fact that their outdoor laboratory is 15 minutes from campus—and that it's not raining.

Crew is one of those activities often called a "minor sport," but not to its participants. Consider it a track meet on water where competitors row on a course just over a mile long. Begun in 1973 with used boats, student interest generated what became the largest club on campus, and the club is self-supporting. Row-a-thons and food concessions provide funding to compete in national events. Crew teams use Humboldt Bay for lots and lots of practice.

What was begun as a wastewater aquaculture project in 1971 by fisheries professor George Allen has become a national model for environmentally responsible wastewater disposal. Allen reared salmonids in a mixture of treated wastewater and bay water with promising results, and the City of Arcata took over the program in 1977. Today the 307-acre marshland is an urban wilderness with 200 species of birds to watch.

Discovering marine biology often involves a lot of "get wet" science. If a person is studying to be a naturalist who will work with children, that person knows that kids like any excuse to get wet, and "belly biology," watching how creatures called beach hoppers act at tide-line, is fun. Being splattered in seawater learning marine biology creates teachers who share their love of the environment and pass it on.

The first Lucky Logger mascot was a nine-foot statue in the men's gymnasium in 1959. He evolved into a huge mask worn by a Humboldt student and has been a fixture at public events, parades, athletic competitions, and dances for decades. Girls used to love to sit in his lap, and children approach him warily, wondering how he got to be so big.

Even with thousands of students swirling around, it is possible to find that private, quiet corner to study, like this seldom-viewed left front corner of Founders Hall. Away from the distraction of friends and chatter, serious focus of attention to the printed word is possible. For decades, students have been finding their own favorite study spots around the campus.

Four thousand pounds of bronze is poured in Humboldt's art foundry, the largest in the California State University system. Sand, mold, ceramic, shell, and lost wax casting methods are explored, as are substances like iron and aluminum. A full array of metal sculpture equipment is available to students.

Anthropology studies the world's diverse cultures in other places, settings, and times. Often the study of bones adds to the understanding of life in the past. Humboldt's unique setting in proximity to nine Native American tribes gives rare opportunities to study and contribute to the interpretation of cultures.

A craft fair on campus can delight a student mother and her child, but the campus also provides the Children's Center program of care and education for toddlers and pre-school children for university students. The university offers majors and minors in child development and education.

This guy better be quick or the owl in the nest box could take a chunk out of his fingertip. The game pens today provide first-hand experience with wildlife for students. Birds and animals here cannot be released back to the wild for a variety of reasons. A huge flight cage and waterfowl ponds are also available.

Tai chi chuan is considered a form of physical education at Humboldt emphasizing precise movement and body dynamics, but some students just consider it fun. All it takes is flat ground and an experienced leader. Here a group uses the Balabans Quad outside the art building.

May Day has always generated festivities outdoors. The rains are over, the sun is out, and it's a good day to dance. Students can earn a minor degree in dance at Humboldt. Styles taught include Latin, country-western, Mexican folkloric, swing, tap, and social dance of the 1930s and 1940s. Kay Chaffey taught dance at Humboldt for more than 30 years.

Center Activities provides equipment rental and instruction for Humboldt students. In one photograph, it captured windsurfing, canoeing, rock-climbing, kayaking, rafting, backpacking, and skiing—13 students and a dog with a Frisbee. Humboldt has traditionally offered a wealth of outside activities along with traditional studies. The Humboldt Bay Aquatic Center in Eureka offers activities, too.

Aerobics class consists of aerobic exercises of rhythmic movements to increase cardiovascular endurance, muscle strength, and flexibility. Powerstep, seen here in 1994, adds traditional aerobic dance steps on and off a step platform. The physical education department also offers strength training, body fitness, and relaxation techniques.

Want to listen to a trio play some Jimi Hendrix on a sunny April day? Start pedaling. In a human energy conversion project, pedaling was turned into the energy to power the amplifiers for music on the quad.

The Peace Corps has attracted more than 700 Humboldt students as volunteers since its inception in 1961. Former Humboldt Peace Corps volunteers return to campus to speak about their adventures and inspire a new generation to join. Bringing along native garb and artifacts made an interesting presentation. In 2009, Humboldt ranked 14th nationwide among medium-sized universities for being a source of volunteers. Humboldt alumni have served in 76 countries.

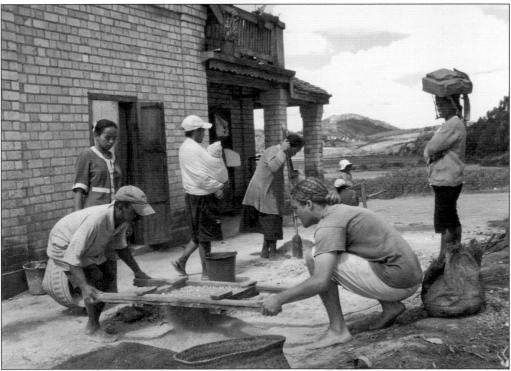

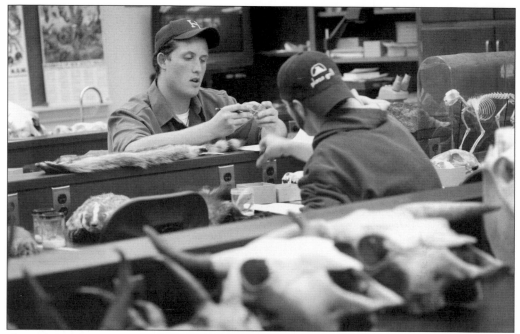

If one has a bone and doesn't know what it is, a place to go where it can be compared to an identified specimen is really helpful. The Vertebrate Museum on campus has 8,000 specimens for inspection with 1,500 more amphibians and reptiles. Now does he have a mole or a vole bone?

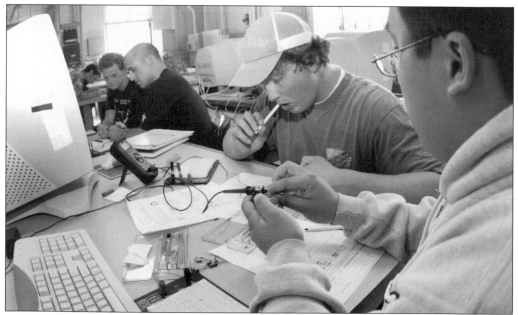

So just what is appropriate technology these days? Humboldt offers a minor in it as part of the environmental resources engineering program, and it allows students to familiarize themselves with new technologies while developing understanding of the political, social, and economic processes by which choices about technologies are made. Classes are taken in engineering, political science, and sociology as part of the program, as students demonstrate here.

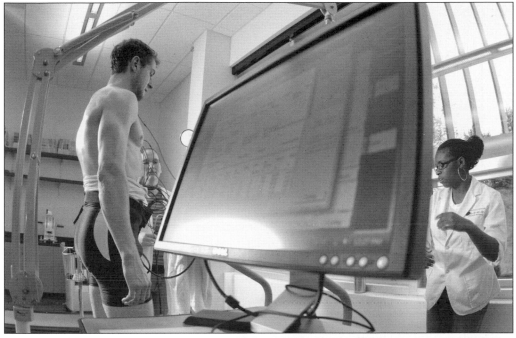

The new $44-million Kinesiology and Athletics building opened in 2008. The Human Performance and Biometrics Labs are recognized as among the best in the California State University system. The building includes dance studios, a pool, and a 17,655-square-foot sports arena. Here a human guinea pig participates in testing in a lab.

In 2008, a new hydrogen-powered car joined the Humboldt vehicle fleet. It fuels up at an on-campus hydrogen station that was inspired by a student design and was the first rural station on California's "Hydrogen Highway."

The Multicultural Center, which houses this impressive staircase mural, provides a meeting place for the culturally diverse Humboldt student community to exchange ideas. Students from all backgrounds gather at the center, which sponsors cultural awareness programs. Prof. Eric Rofes dedicated his life to social activism and worked with the center to create a place where knowledge from different perspectives could be shared constructively.

The Department of Theatre, Film, and Dance has a class to teach students the makeup techniques this student is exploring, and a class in theater movement and mime would put such a distinctive face before an audience. Costume design, mask-making, and 3-D makeup are also offered.

Juggling has been a passion to some and a spectator sport to others on Sequoia Quad since math professor Phyllis Chinn introduced the pastime to an informal club in the 1980s. Mathematicians like the patterns found in juggling. Chinn could juggle knives and torches, but students start with balls and clubs.

Humboldt has been renowned for teaching many things, but does that include beekeeping? Yes, if Bob Hite is instructing and if it's an extended education class. This program offers classes for teachers and seniors and features continuing education and certification programs. The Osher Lifelong Learning Institute offers thought-provoking and fun classes for those over age 50.

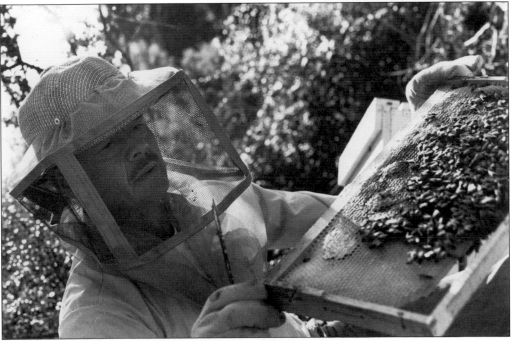

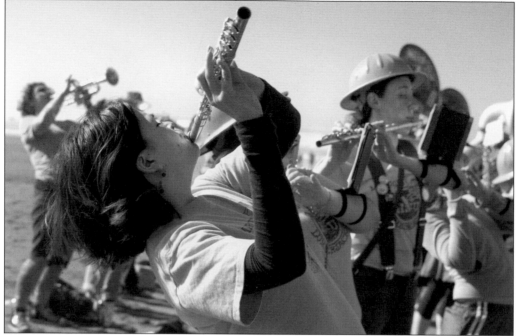

Strutting to a beat all their own, the Marching Lumberjacks band prepares to march into the Pacific Ocean for a bit of fun. That's what being in the band is all about. In 2008, they celebrated their 40th anniversary on campus. Holding their reunion during a rain-soaked night of football, 150 people showed up with well-worn instruments to perform at halftime. What they lacked in practice time, they made up for with enthusiasm. They are a student-supported scatter band that abandons conventional marching behavior for random scattering formations. They wear green and gold and hard hats. They have an ax major instead of a drum major. They can play 100 songs and are the musical support group at athletic competitions. They're unique.

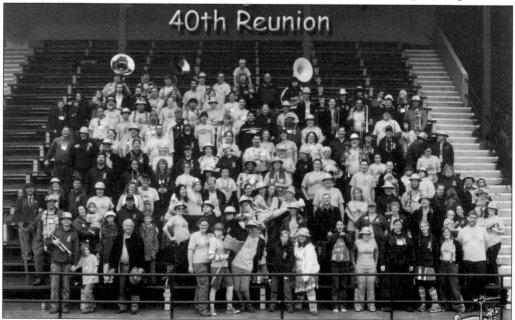

As special to the Humboldt campus as the gigantic Lucky Logger, the Marching Lumberjacks have a style all their own and a loyal following. Using the term "unconventional" would be putting it mildly. They may look scruffy and act strange, but they play great music and cheer up a crowd. They have their own alumni group and hold reunions.

Youth Educational Services has celebrated its 40th anniversary on campus. It offers student-directed programs for volunteers to address social issues and unmet needs in the community. Dozens of programs complement classroom learning, offer leadership opportunities, and foster respect for human diversity. Here volunteers teach children the intricacies of Maypole dancing.

Celebrating their national title in 2008, the Humboldt softball team possesses decades of championship wins. The team won 19 conference titles, four NCAA West Region titles, and a previous national win in 1999. Coach Frank Cheek has over 1,000 victories for his team. The games are a very popular spectator sport on campus.

This university's reputation for strong natural sciences programs was reinforced by a 2009 *National Geographic* cover story about redwoods. The article and related documentary featured Humboldt professor Stephen Sillet, who has conducted groundbreaking research on redwood treetop canopies. Professor Sillet holds Humboldt's first endowed chair, the Kenneth L. Fisher Chair in Redwood Forest Ecology.

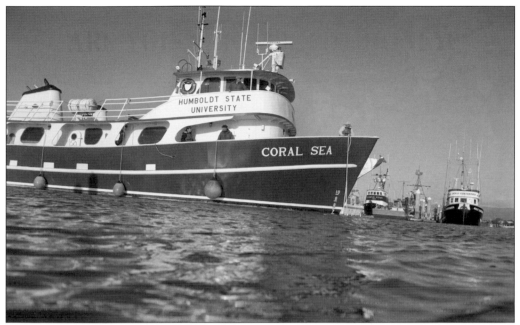

Humboldt is one of the few universities in the nation to have an ocean-going research vessel for undergraduate research. The R.V. *Coral Sea* has space for 39 students and scientists in addition to five crew members.

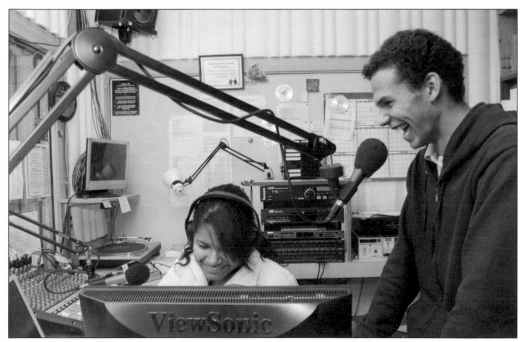

In recent years, Humboldt has been attracting an increasing number of international students, including this duo shown hosting a radio show on the campus-based public radio station KHSU. World music themes on KHSU in the 2009 programming include Afro-pop, Brazilian, Celtic, Latino, and ethnic musical excursions around the world.

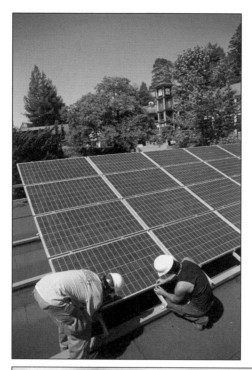

Humboldt students have long had an interest in sustainability. In 2007, students approved a fee that launched the Humboldt Energy Independence Fund. It pays for student-designed clean energy projects on campus, such as this solar power array and solar-themed art project atop the old music building.

Humboldt is among the leading universities nationwide awarding bachelor degrees to Native American students including Brrannon Fraley, Tolowa. In fact, Humboldt's Native American Studies program is unique in the state higher education system. Groups like Indian Natural Resource Science and Engineering and the Indian Teacher and Educational Personnel Program prepare native students to make a difference in the world. Many students celebrate graduation by using traditional materials and techniques to make intricate sashes that adorn their caps and gowns.

Maybe Dad looks a little funny dressed in black with a funny hat. Kenneth Hinman holds son Todd after his 1963 graduation, in which he received a bachelor of arts teaching credential. Babies have been passed from the onlookers to marching graduates and carried on stage during commencement while the proud parent collects a diploma.

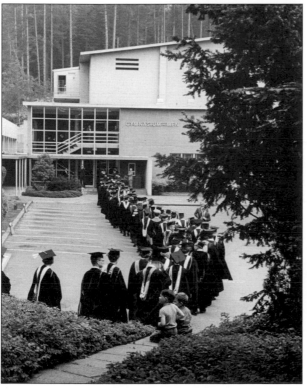

The procession of students and faculty in caps and gowns heading for graduation ceremonies has been a tradition for almost a century now. Commencement ceremonies moved outdoors in 1960 as they grew ever larger, and today, separate graduations for departments occur all day long. Little kids wait with excitement to see their family members march by.

President McCrone shakes the hand of Norma Tucker in 1980 as he awards her a bachelor of arts in music. Humboldt educates many reentry students who return to college, often after child rearing or retirement. Humboldt offers an over-60 program allowing seniors to work on degrees for a nominal fee.

The pride family members feel at graduation never changes. One may be a grown man, but that isn't going to stop someone patting him on the cheeks and telling him how proud they are of him and how special he is and how far he will go in his chosen career.

The Humboldt Graduation Pledge says, "I pledge to thoroughly investigate and take into account the social and environmental consequences of any job opportunity I consider." It is the last promise a graduate makes to Humboldt. With diploma in hand, the graduate can voluntarily choose to accept the pledge card. Adopted by the student body in a vote in 1987, it is an element of the graduation ceremony. The students, faculty, and community members in the Student Citizens for Social Responsibility group on campus came up with the wording. From Harvard to Stanford and Columbia, this pledge of social and environmental responsibility has spread to hundreds of university graduation ceremonies around the world. Students wear the green ribbon on their gowns with pride and commitment.